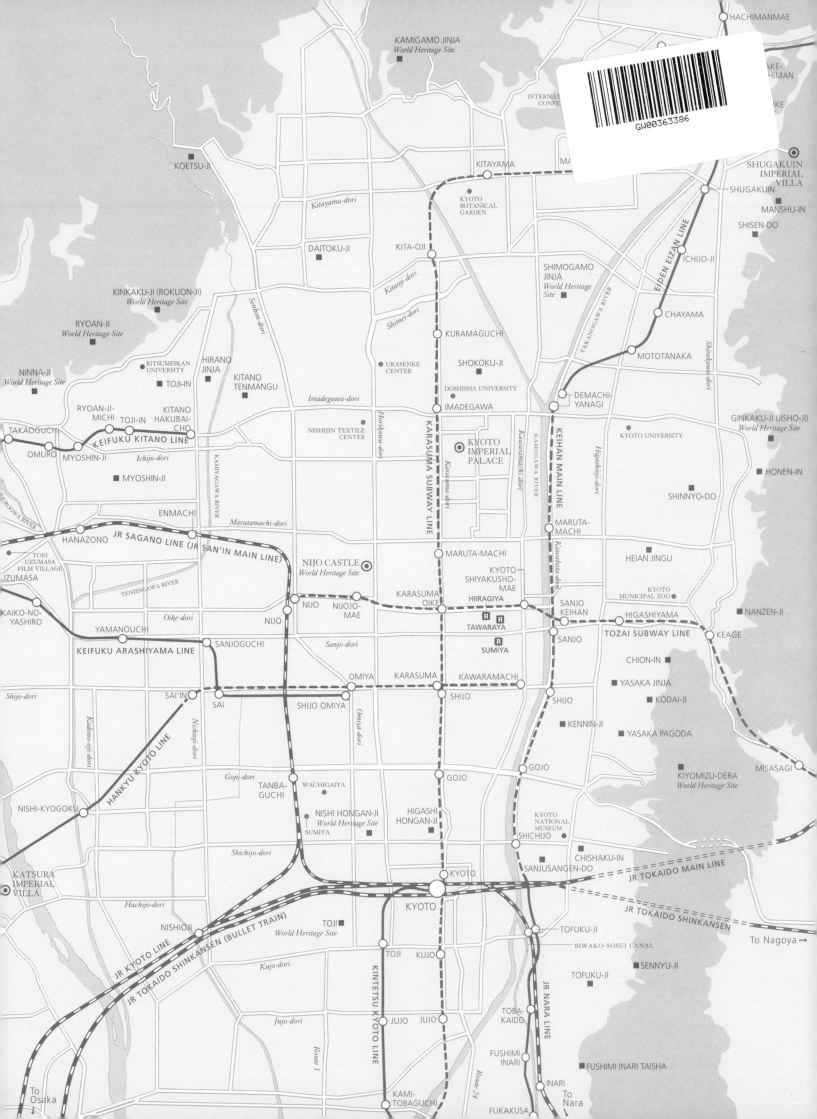

SEEING
KYOTO

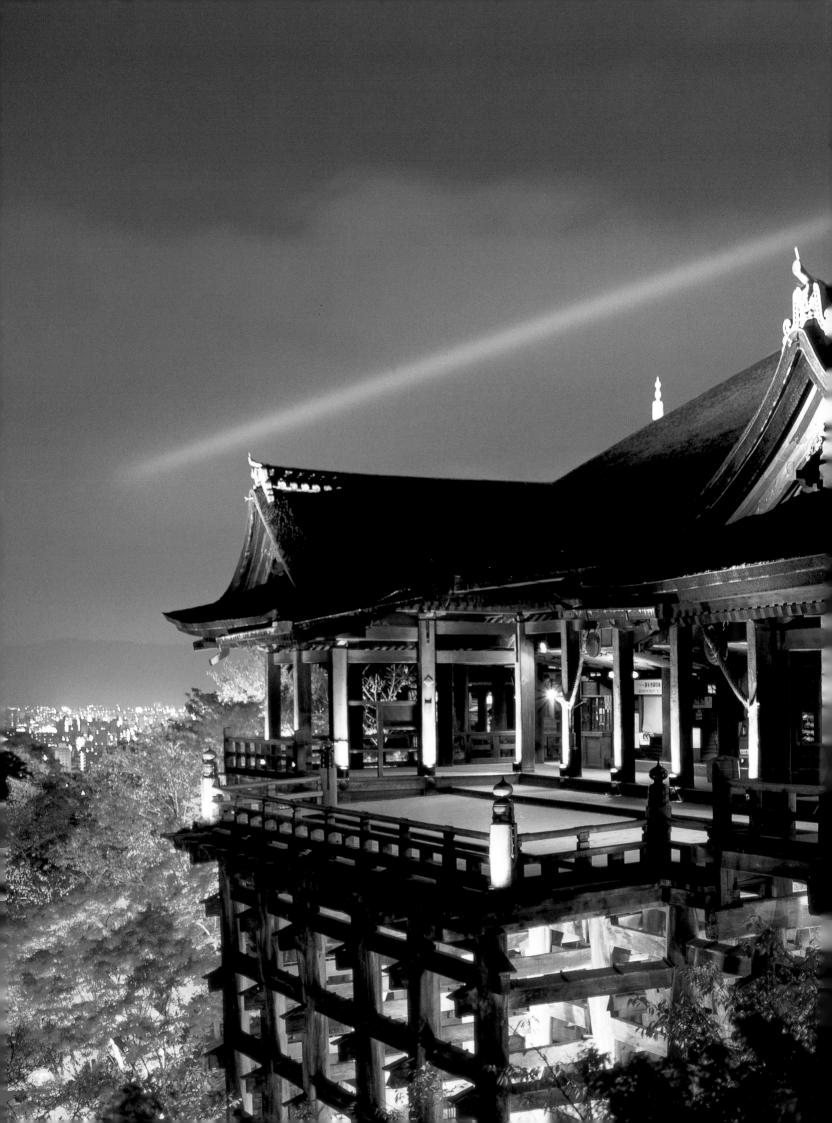

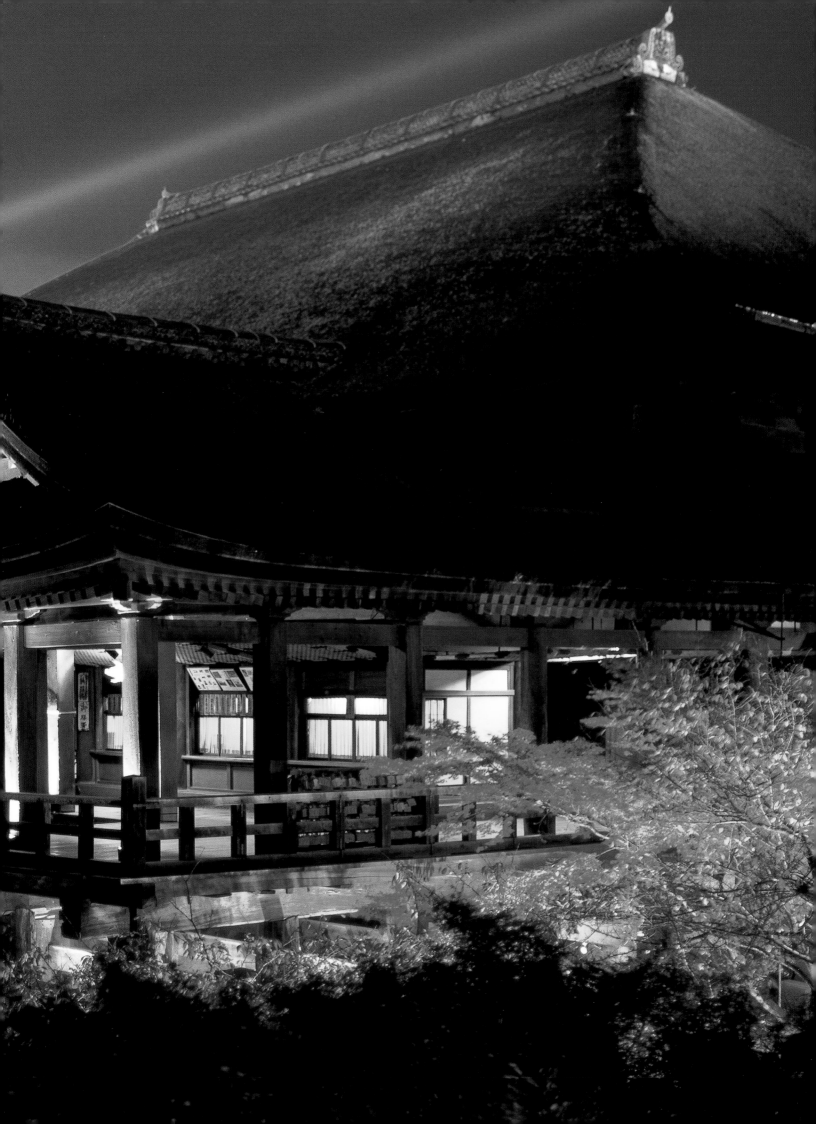

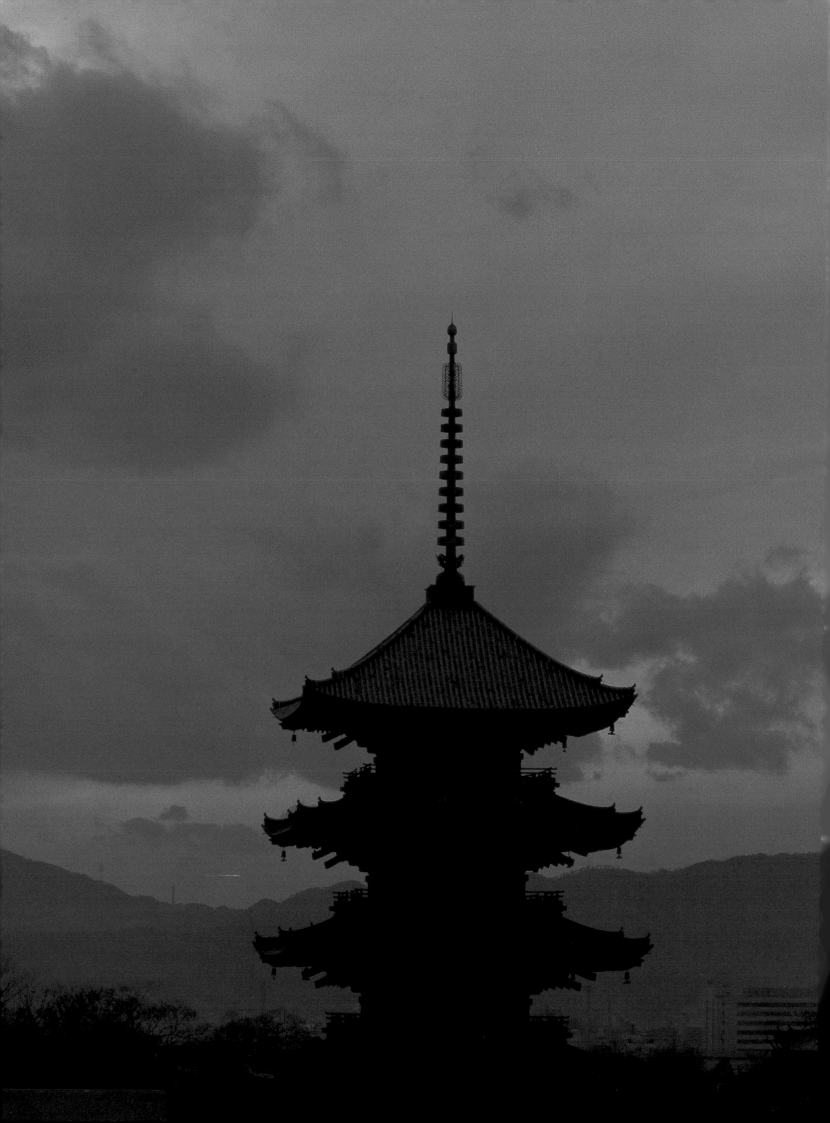

SEEING KYOTO

TEXT BY Juliet Winters Carpenter

FOREWORD BY Sen Soshitsu

KODANSHA INTERNATIONAL
Tokyo • New York • London

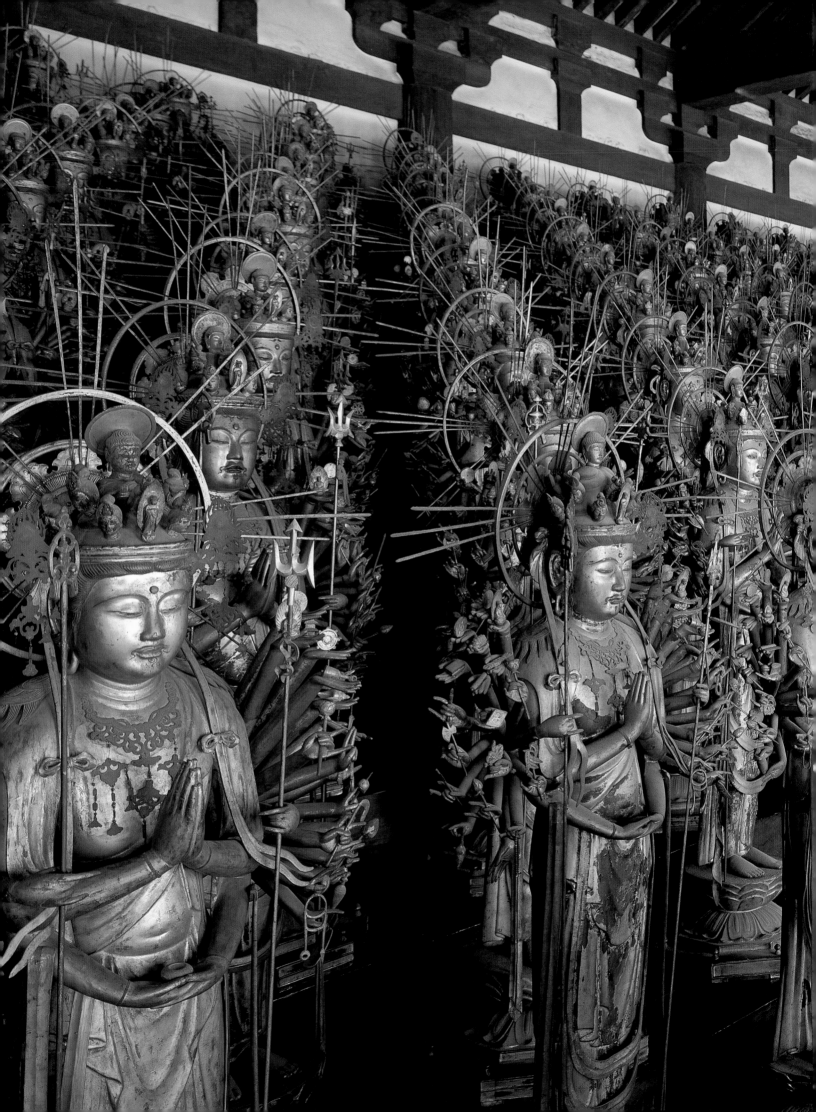

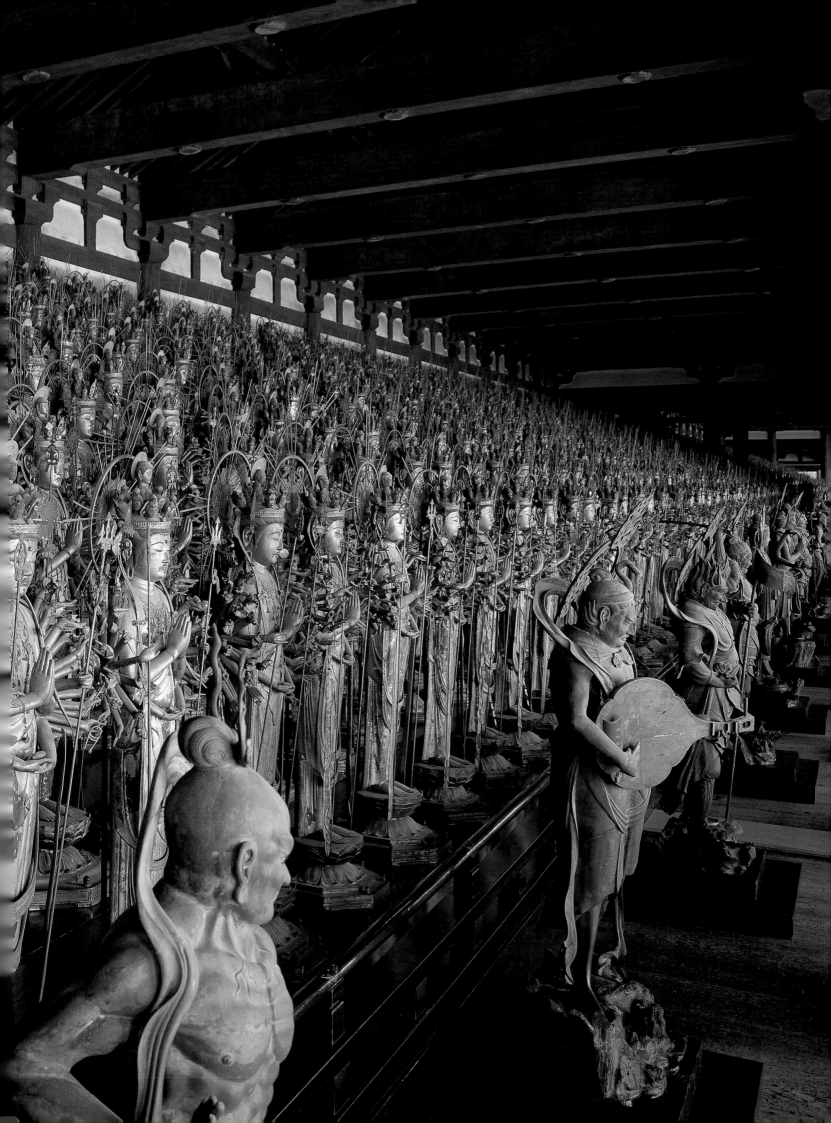

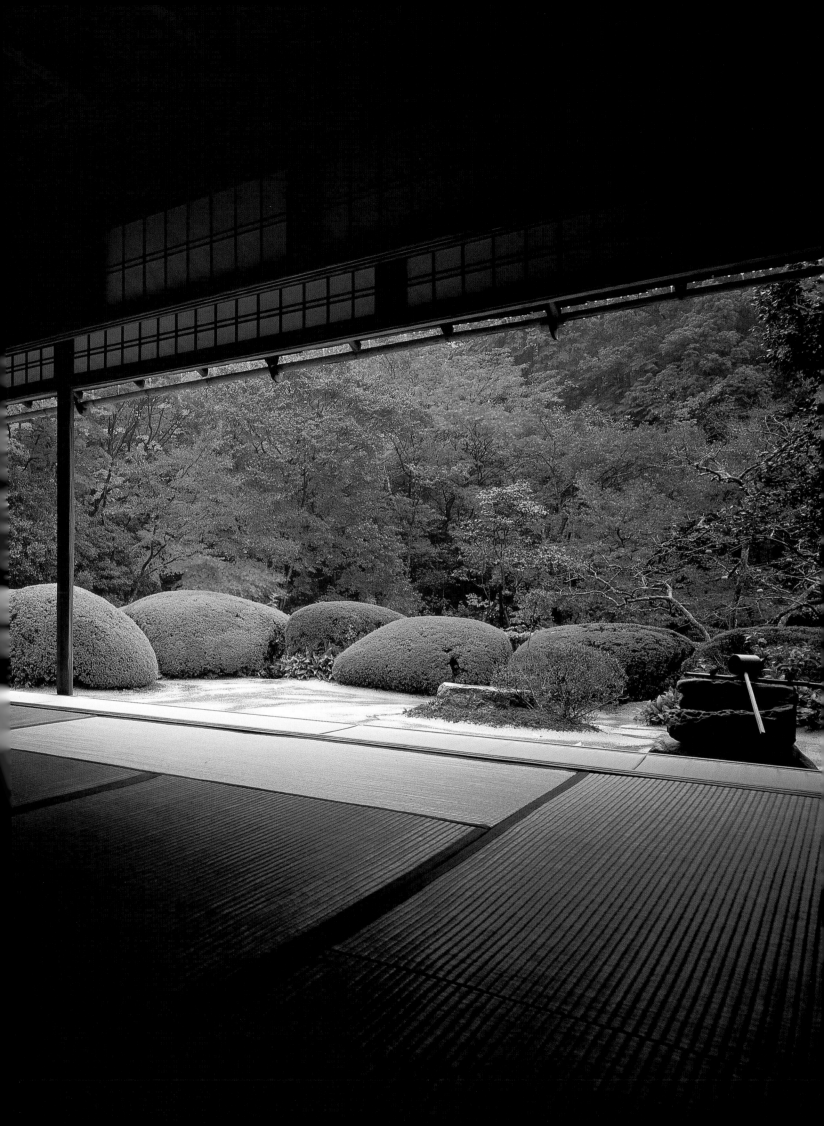

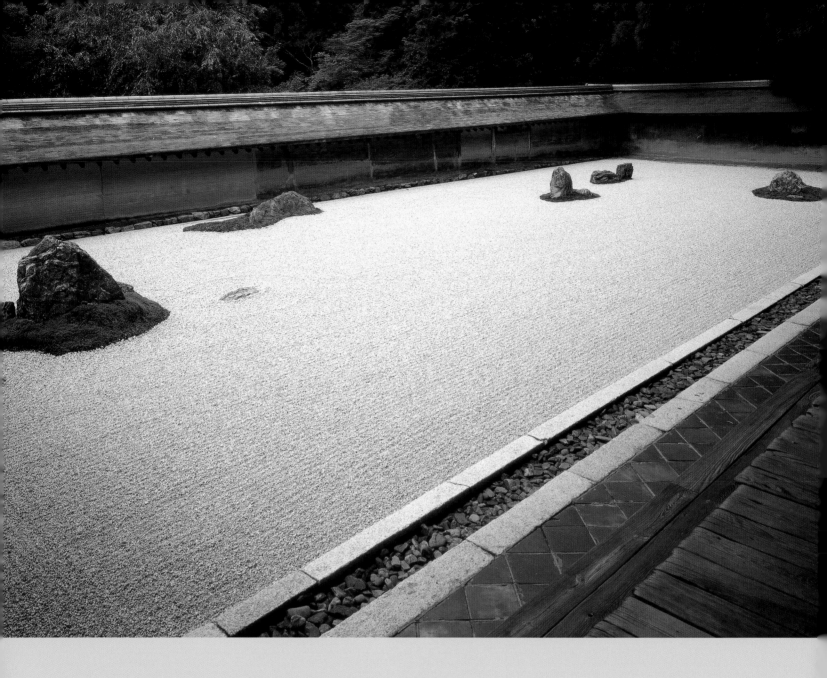

Note: Exclusive of some names on the back jacket flap, all Japanese names are rendered in the traditional Japanese manner, surname preceding given name.

Distributed in the United States by Kodansha America, Inc., and in the United Kingdom and continental Europe by Kodansha Europe Ltd.

Published by Kodansha International Ltd., 17–14 Otowa 1-chome, Bunkyo-ku, Tokyo 112–8652, and Kodansha America, Inc.

ISBN 978–4–7700–2338–4

First edition, 2005
15 14 13 12 11 10 09 08 07 12 11 10 9 8 7 6 5 4 3

PAGE 1: Red maple leaves against blinds.
PAGES 2–3: The main hall of the temple Kiyomizu-dera, lit up at night.
PAGES 4–5: The five-story pagoda of the temple To-ji under a full moon.
PAGES 6–7: Statues of Thousand-armed Kannon in the temple hall Sanju-sangen-do.
PAGES 8–9: Autumn foliage in the temple garden of Shisen-do (Poets' Hall).

ABOVE: A rectangle of raked sand and stones on temple grounds: the Zen garden of Ryoan-ji. **RIGHT, TOP TO BOTTOM:** Pink plum blossoms at the shrine Kitano Tenman-gu. Cascading wisteria at the Kyoto Imperial Palace. A fence of woven bamboo in the tea garden of the temple Koetsu-ji.

www.kodansha-intl.com

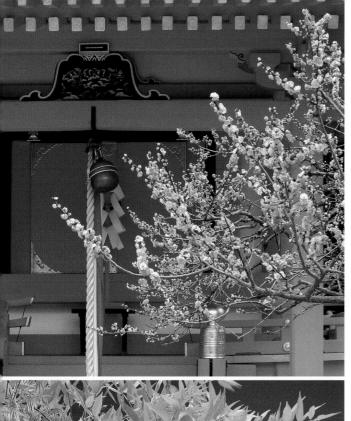
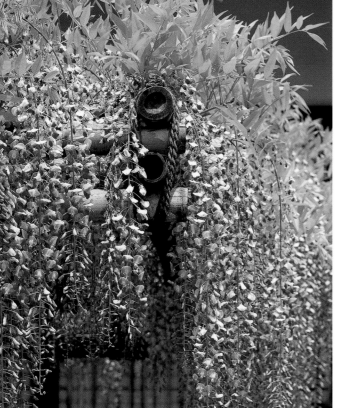
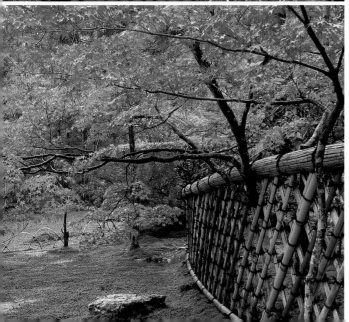

CONTENTS

FOREWORD

Sen Soshitsu

Who counted the Eastern Hills?

Stand in Kyoto, at a spot that affords a good view, and face east. Your right eye will then take in Mt. Daimonji and your left Mt. Hiei.

Cocky little Mt. Daimonji looks northeast, while Mt. Hiei towers diagonally across from it. The gently undulating prominences between them are known as the Thirty-six Peaks of Higashiyama, the Eastern Hills. No one in particular seems to have counted them, but the expression has a pleasant ring. It occurs in this work by Chinese poet Li Bai:

SONG OF YUAN DANQIU

Yuan Danqiu,
You love divine immortals
Who drink in the morning the river Ying's pure waters
And at sundown return to Songcen's purple mists.
The thirty-six peaks range far on all sides,
Range far on all sides.
Treading stars and rainbows,
You ride a flying dragon, the wind in your ears,
Crossing rivers, straddling seas, rising to the heavens,
And I know how boundless is your will to roam.

This poem celebrates the untrammeled life led by Li Bai's friend Yuan Danqiu, a great lover of the realm of the immortals, beside the Song Mountains and the river Ying. No doubt the Song Mountains, with their thirty-six peaks, are a nobly dignified range of hills. Perhaps this really is where the tag expression "the Thirty-six Peaks of the Eastern Hills" comes from, but no one knows for certain.

Travelers have always been extravagant, pursuing things that do not exist. For example, while contemplating the fresh color of new leaves, peeping out from between evergreens, they let their thoughts fly to the season when trees flame with fall colors. In the realm of the Eastern Hills, the seasons pass swiftly from peak to peak. One can only be grateful to meet them on their way, fleeting as a maiden's modest blush. So sling that camera of yours over your shoulder and spend the day roaming from south to north along the foot of the Eastern Hills. Start near the temple Honen-in, if you can. You might go as far as Iwakura, which stretches northward from the east. The route is easy enough by bicycle, too, if you have one, and you will find many photogenic scenes along the way. The best season is spring to early summer. High summer will do as well, though, when great thunderheads rear up from between the hills; so, too, will autumn, when the hillsides are dyed in red and gold. Each of these seasons has its charm. But winter: well, it *is* cold—rather too cold for bicycling. That above all explains why I, lacking a driver's license, find in my photograph album almost no winter landscapes. Another reason is that the places where I feel like taking a picture are almost always unreachable by car.

The river runs forever

To the south, the land opens out. There are no mountains. Until the early twentieth century a vast lake, ten miles (sixteen kilometers) around, apparently lay in the broad plain that stretches on toward Nara. Ogura-no-ike, it was called. It was quite impressive. Alas, it fell victim to land reclamation.

Despite its disappearance, however, something of it still lingers on in the climate of Kyoto: humidity. Not that the air is saturated every day of the

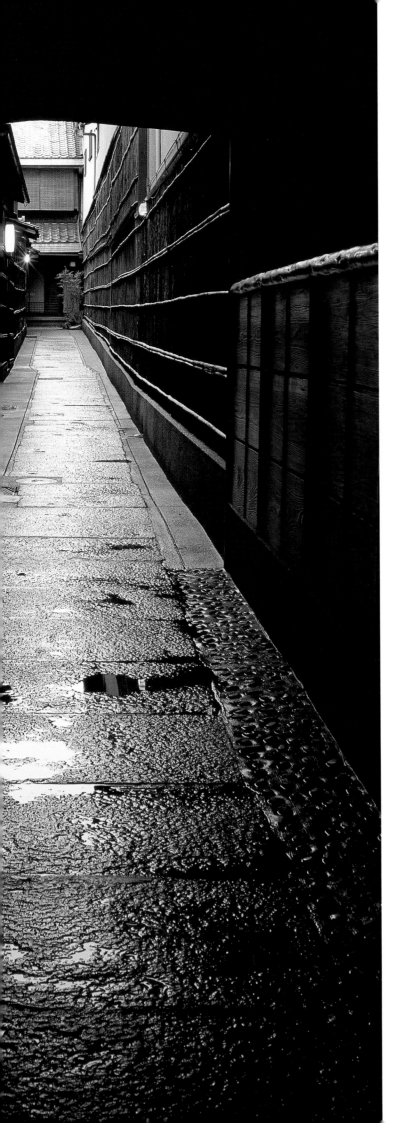

year; it is more that Kyoto is blessed with atmospheric moisture in just the right degree. Take winter in a city along the Pacific coast, for example. Your skin feels the dryness the moment you come out of Tokyo Station, and you can almost hear the tiny crackling sound as it dries.

The ample streams that flow from Kitayama, Kyoto's Northern Hills, converge in the Kamo and Takano rivers, which bring the city water. Along their banks cherries blossom in spring, followed by a shifting succession of flowers from early summer through autumn. In midwinter, so severe and spiteful a season that no trace of all those flowers remains, flocks of gulls delight the eye as they wheel and turn over the river, as though chasing dancing flakes of snow; and in that instant the season changes once more to spring. The Hozu River, too, joins in blessing Kyoto with a bounty of water. The city lies within the mountains as though held in a loving father's embrace, while the rivers carry their nourishing water, like mother's milk, to every nook and corner.

What makes a Kyotoite?

No one from beyond the seas can possibly be drawn to Japan merely to see Mt. Fuji or geisha, but these words' mysterious resonance surely conveys nonetheless a richly exotic charm. There are so many travelers, camera in hand, at the south Gion crossroads, eagerly waiting for a *maiko* or a geisha to appear! To someone from elsewhere, any girl in white makeup and a trailing sash must, alas, look like a *maiko*; and that is why the false *maiko* so common lately attract excited crowds. These characters are little more than aging imposters who spend most of their time lying around watching daytime TV, while stuffing themselves with junk food. They stride brazenly down the streets of the quarter, trailing their escort of tourists, in a manner wholly out of keeping with the kimono they wear. They are an embarrassment. One way to tell the false from the genuine is that no real *maiko* gestures while she walks. Also, she never takes a step long enough to divide her kimono skirts. And then—a small point, but a telling one—she wears no watch or ring, and she does not have pierced ears. She does not glance restlessly around her, either. Well, you will not go far astray if you remember that much.

The history of Kyoto, more than twelve hundred years old, is not one of showoffs and curiosity seekers. For those who wish to drink from the city's cask, its culture makes a most fragrant wine. Many cultural pursuits, matured over all those centuries, still live and breathe throughout the city. The real entertainment quarter, for example, is no red light district. Its geisha and *maiko* are not there to pour your wine. Yes, it offers food and drink, but above all it offers their dances, and the chance to hear and learn the traditional songs that they sing.

Perhaps not every Kyoto resident has mastered every nicety of correct procedure, but most know how to enjoy the cultural pastimes so deeply rooted in local life: the arts of tea, flower arrangement, and incense appreciation. All these appeal to a common delight in the region's four seasons. Nothing in them either clashes with the seasons or obscures them. The backbone of traditional culture is understanding the proper way for people to come together. The simple gesture of offering a bowl of *matcha* tea surely involves less tension here than it would anywhere else. "You'll have some, won't you?" they say in their soft accent, and that is really all there is to it.

The world has changed, and so too Japan, but Kyoto does not change. No doubt some towering structures have started appearing among the low *machinami* houses inherited from the past, but between them the residents of Kyoto, to whom the four seasons are friends and neighbors, retain the disposition that has always been theirs. O traveler, I wish you easy meetings with them at the corners of our streets.

A narrow lane in the Kiyamachi district at twilight.

INTRODUCTION

My first visit to Kyoto was in spring 1960, an astonishing forty-five years ago. My father and I rode down from Tokyo on the train—not the bullet train, which had not yet been invented, but a very comfortable train nonetheless. I remember that next to my seat was a tall glass containing dry leaves in the bottom, which had me mystified until—*presto!*—a woman came around and filled it with hot water, making tea. I can also remember the excitement of passing Mt. Fuji, serenely magnificent against a blue sky—and my despair on realizing I was out of film. I was just a little girl, but these memories are extraordinarily vivid.

The Kyoto we eventually saw also left me with indelible images of beauty wrapped in the mystery of an unknown culture: the glow of golden statues inside dark temples; paper doors painted in rich splashes of color; women in straw hats on their knees, using tiny scissors to trim grass in the Imperial Palace grounds. I had one of my first Japanese lessons, learning that whereas people in Tokyo said *arigato* for thank you, in Kyoto there was another word: *okini*. The clip-clop of wooden *geta* sandals was everywhere and I begged my father for a pair, which I still own.

My second visit came a decade later, on a weekend getaway with fellow Americans studying Japanese in Tokyo. This time we stayed in a temple and rode the old streetcars all around the city, visiting landmark spots that I knew something about from college courses in Japanese history, literature, and art. This time there was the thrill of recognition, and of discovering what else there was that the textbook, or slide lecture, had been unable to capture. Although I managed to get lost, and missed the train back to Tokyo, it was an otherwise perfect experience.

Except for the *geta* and the streetcars, all the things I remember best about Kyoto from those early visits are still there, timeless and unchanged. The city still waits to share its riches with all who come—whether newcomers to things Japanese, serious students, or old Japan hands (or, of course, native Japanese)—and leave them with memories that will last a lifetime.

That the ancient capitals of Kyoto and Nara have managed to preserve their character to such a degree is truly amazing, and in part due to Henry L. Stimson, the U.S. Secretary of War during World War Two, who single-handedly intervened to prevent the bombing of Kyoto's artistic and historical treasures. Together, the two imperial cities remain home to the enduring monuments of Japanese culture and tradition.

It is good to remember, though, that the significance of the region extends even beyond its seminal contribution to Japanese history. As the terminus of the Silk Road, Nara became a nonpareil repository for the culture of lands across Asia and beyond. It has withstood abandonment, fires, and wars to preserve Buddhist and continental art and architecture from the China of the Six Dynasties (222–589), Sui Dynasty (581–618), and Tang Dynasty (618–907). The culture of Kyoto, too, with all its flowering of artistic creativity, is not insular in character but open and international; as one example, some of the most prominent floats in the Gion Festival proudly bear Belgian tapestries from the sixteenth century, or similar artifacts. In the cultural marvels of this amazing city there is common ground for all.

I sincerely hope that those who read this book may be inspired to start, or renew, their own journeys of discovery to the many worlds of Kyoto and Nara.

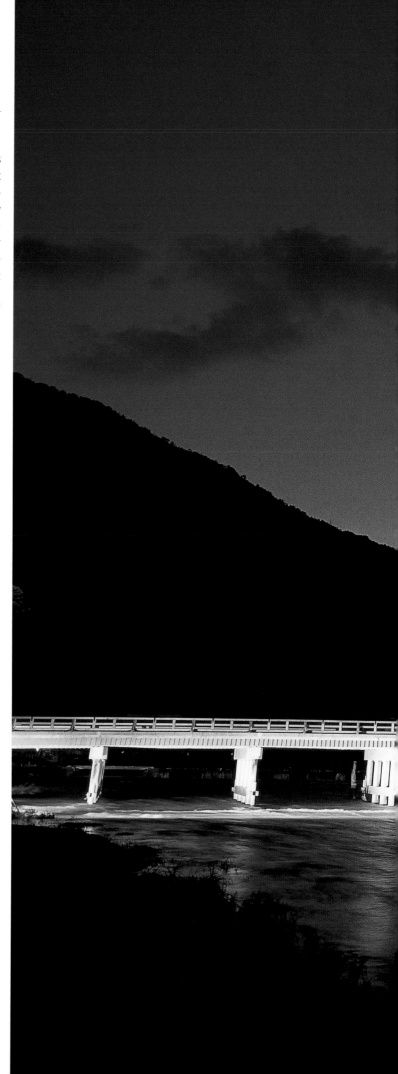

The Togetsu (Moon-crossing) Bridge in Arashiyama, over the Katsura River.

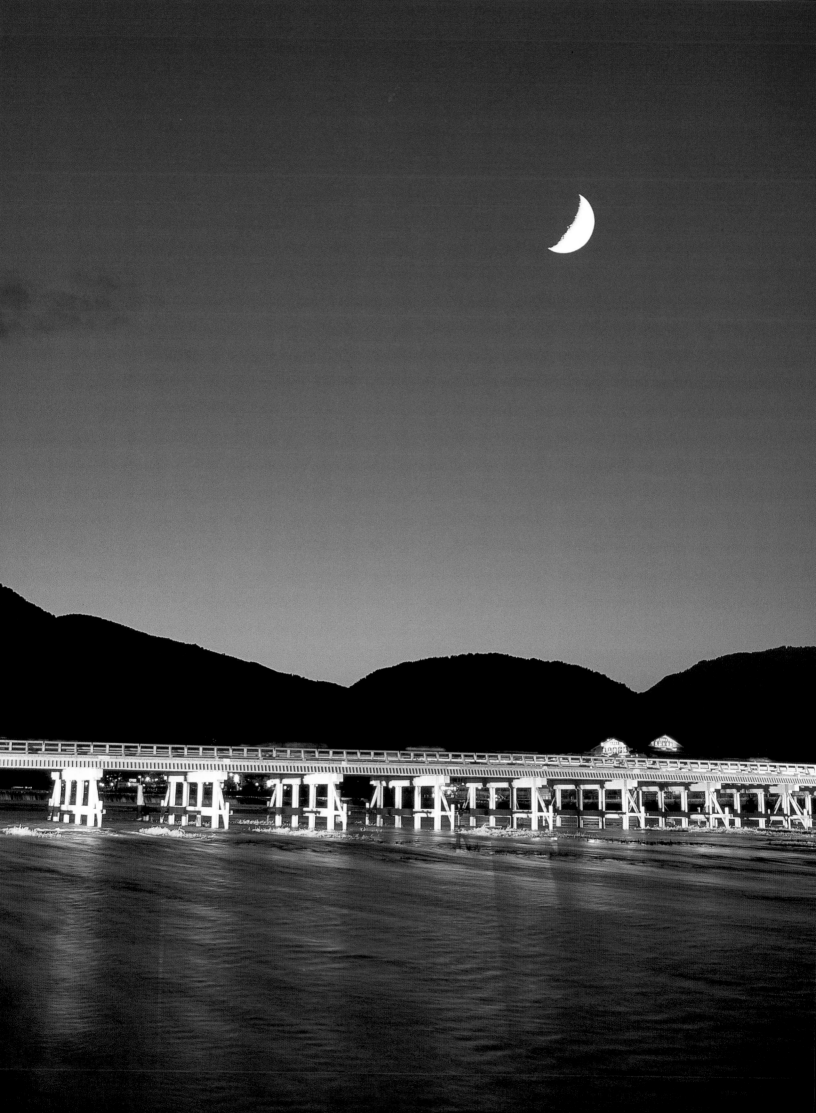

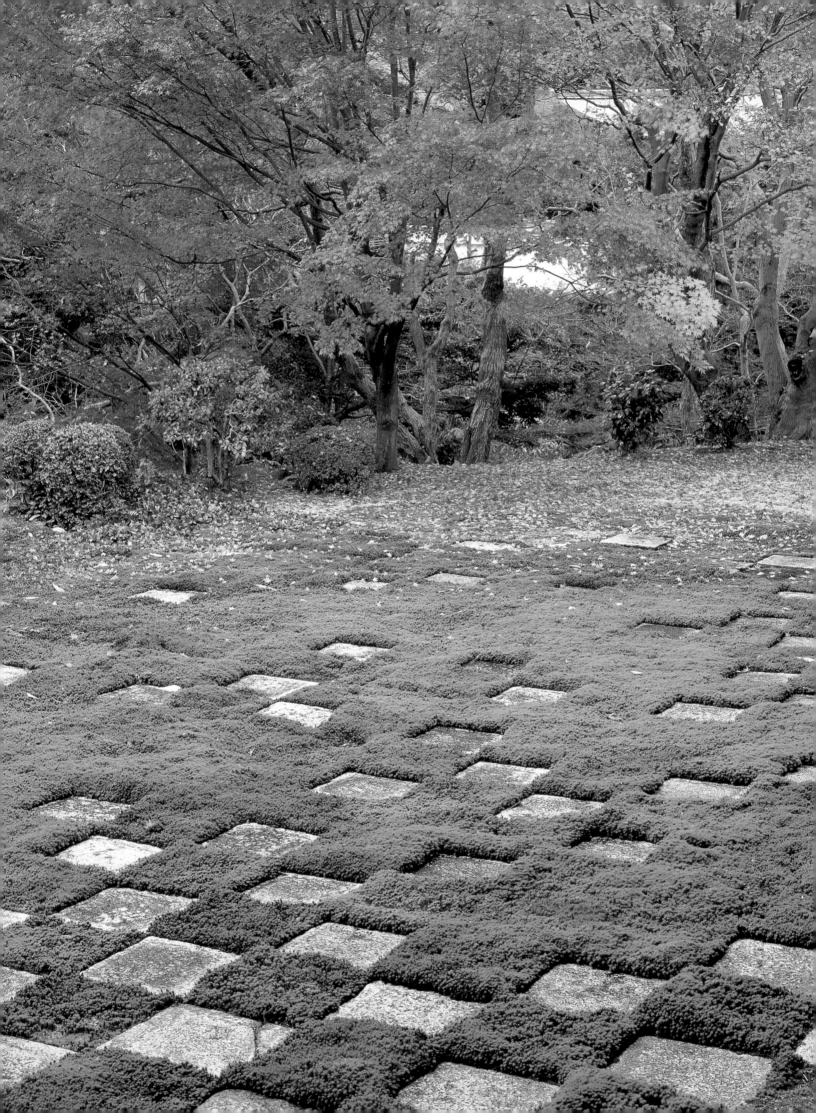

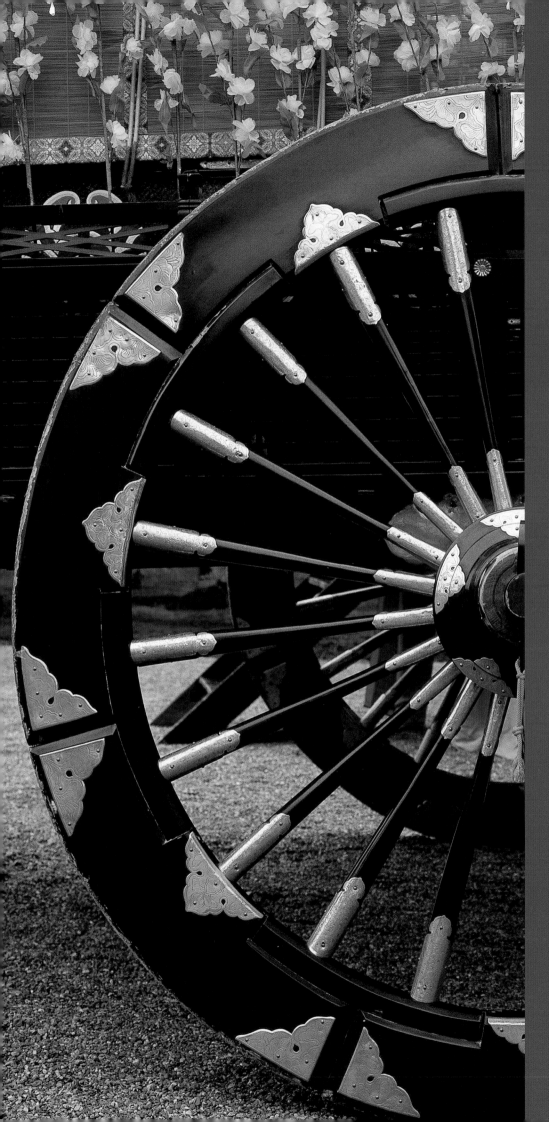

PART I

KYOTO IN HISTORY

In 1994, Kyoto festively celebrated the twelve-hundredth anniversary of its birth as the imperial capital of Japan. Just three years later, the Kyoto Protocol laid out tough international standards on CO_2 emissions, making Kyoto known far and wide as the modern, forward-looking city that it is—and yet the old capital cries out to be known also for the depth of tradition it embodies. With a history as rich as that of any city on earth, Kyoto today is a microcosm of the best of Japan's many gifts to the world. To the Japanese themselves, it represents an ideal of tradition and refinement. With almost two thousand Buddhist temples and Shinto shrines, the city is home to twenty percent of the nation's National Treasures, fifteen percent of its Cultural Properties, and seventeen World Heritage sites. Kyoto is an unsurpassed storehouse of Japan's religious, artistic, and cultural heritage.

LEFT: Decorated imperial carriage used in the Aoi Festival. **FAR LEFT:** Temple garden of the chief abbot's chamber in Tofuku-ji.

THE HEIAN PERIOD
(794–1185)

The story of Kyoto begins late in the eighth century, when it was common to literally pack up the imperial capital and move it to a new, untainted location whenever some malign influence grew too strong. The first semipermanent capital was established in 710 in Nara (Heijo); seventy-four years later, in an attempt to escape the influence of corrupt and meddlesome Buddhist monasteries, the emperor Kanmu (reign, 781–806) relocated the capital in nearby Nagaoka. Only ten years later, in 794, it was moved another short distance and renamed Heiankyo, or Capital of Peace and Tranquility.

The inland location of Heiankyo (later Kyoto) was chosen for reasons having to do with Chinese geomancy: it was ringed with mountains on three sides, with dominant Mt. Hiei a reassuring presence in the unlucky northeast. The arrangement of the Kamo and Katsura rivers in the fertile valley was also thought to be auspicious. The emperor is said to have been delighted with the site, as "the mountains and rivers make it a natural fortress."

The large new capital was laid out on a grid in the style of the Tang Chinese capital Chang-an, with long streets intersected by wide avenues that the nobility traversed in ox-drawn carriages. Measuring nearly three-and-a-half miles north to south and three miles east to west (4.8 by 5.6 kilometers), the city was surrounded by an earthen wall containing eighteen gates. In the northernmost part of the city was the imperial enclosure. An enormous avenue over two hundred and fifty feet wide (seventy-six meters) led south from it to an ornamental gate called Rajomon—better known to the world as Rashomon, the title of a 1950 movie masterpiece by film director Kurosawa Akira. Most of the city was residential, with

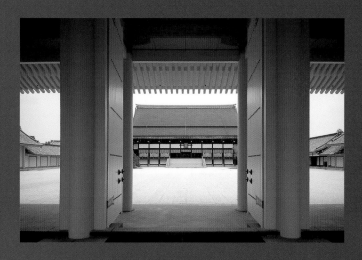

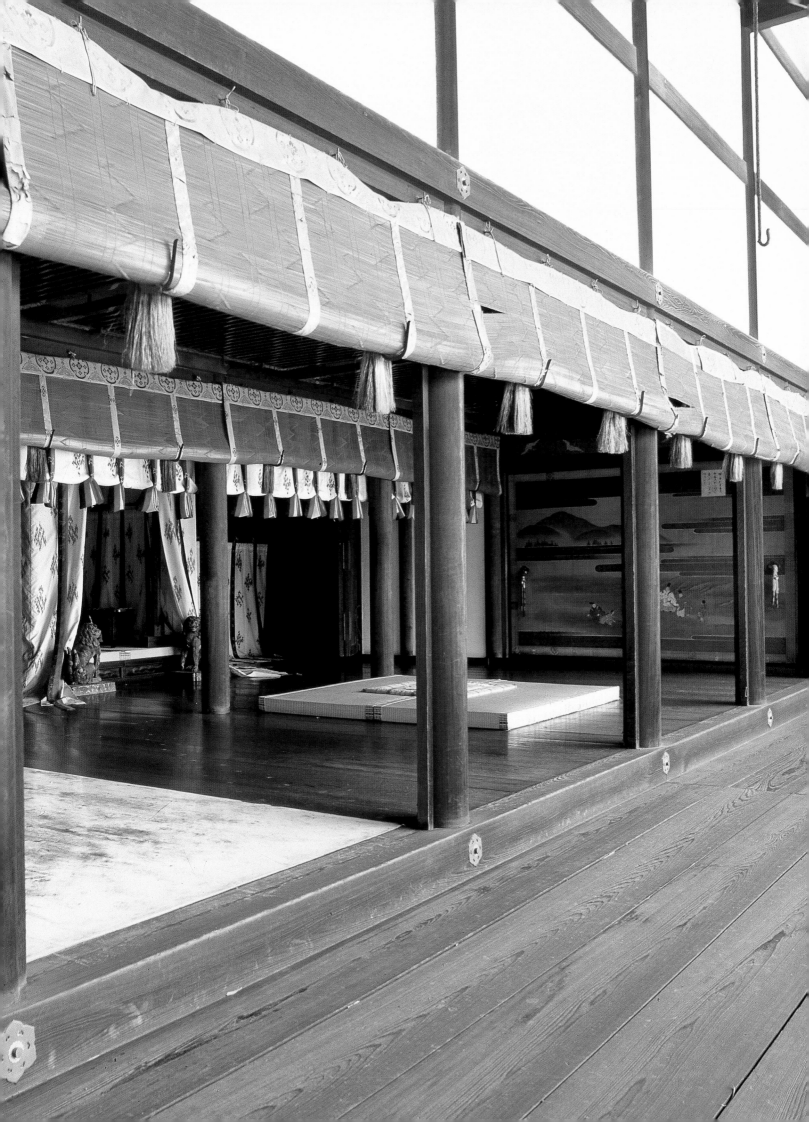

only two temples allowed within the city limits, one on either side of the main gate. Outside the city, Mt. Hiei became the home of the Enryaku-ji monastery, headquarters of the Tendai sect—still one of the most venerable of all holy places in Japan.

During the four centuries of the aptly named age of Peace and Tranquility, Heiankyo thrived as a cultural, commercial, and political hub. In the preceding Nara period, the influence of Chinese culture had been paramount; now, native arts and literature came into their own, spurred by the development of a new, distinctively Japanese system of writing called *hiragana*. Once-frequent embassies to Tang China died away.

The Heian period reached its zenith during the time of Fujiwara no Michinaga (966–1027). The Fujiwara clan managed to increase steadily in power by supplying its daughters as imperial consorts; by Michinaga's day the emperor had become a figurehead controlled by Fujiwara regents, who kept a firm hand on affairs of state.

One of Michinaga's rural villas was converted to a temple by his son Yorimichi in 1052. The Phoenix Hall of that temple, the Byodo-in, is featured on Japan's ten-yen coin. Designed to resemble a phoenix with wings outspread, poised as if just alighting, the hall contains exquisite Heian Buddhist sculptures, carvings, and paintings, as well as one of the country's finest temple bells. The original complex was modeled on the Pure Land paradise of Amida Buddha—an earthly representation of heavenly delights.

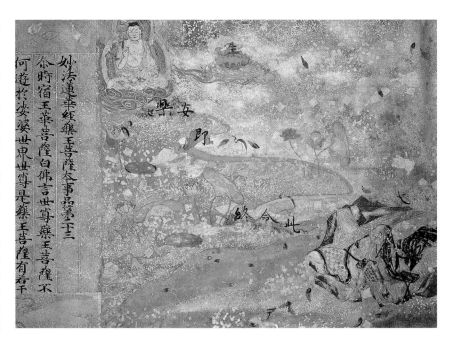

Elegant art of the times. **ABOVE:** End of a sutra copy given to Itsukushima Shrine in 1164 by Taira no Kiyomori. **BELOW:** *Waka* poetry by courtier-poet Oshikochi no Mitsune, from a decorated book in the multivolume of the *Sanjurokunin-kashu* anthology, housed at the temple Nishi Hongan-ji. **RIGHT:** *Womb-World Mandala* from *Mandala of the Two Worlds*, at the temple To-ji.

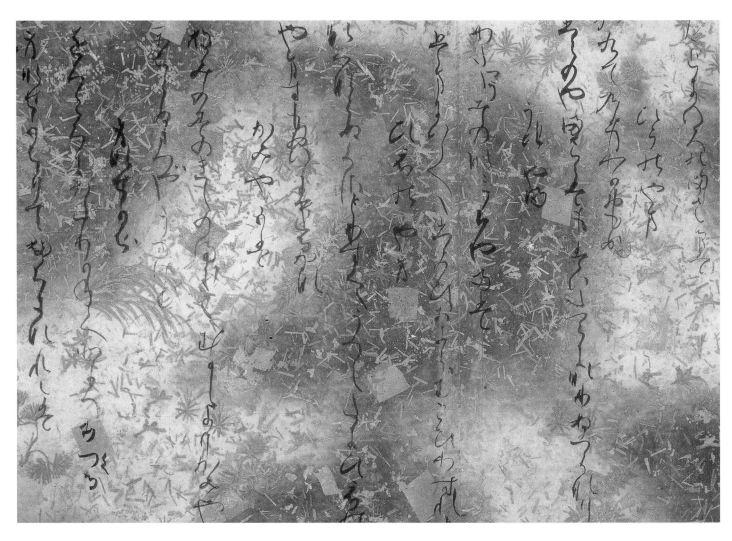

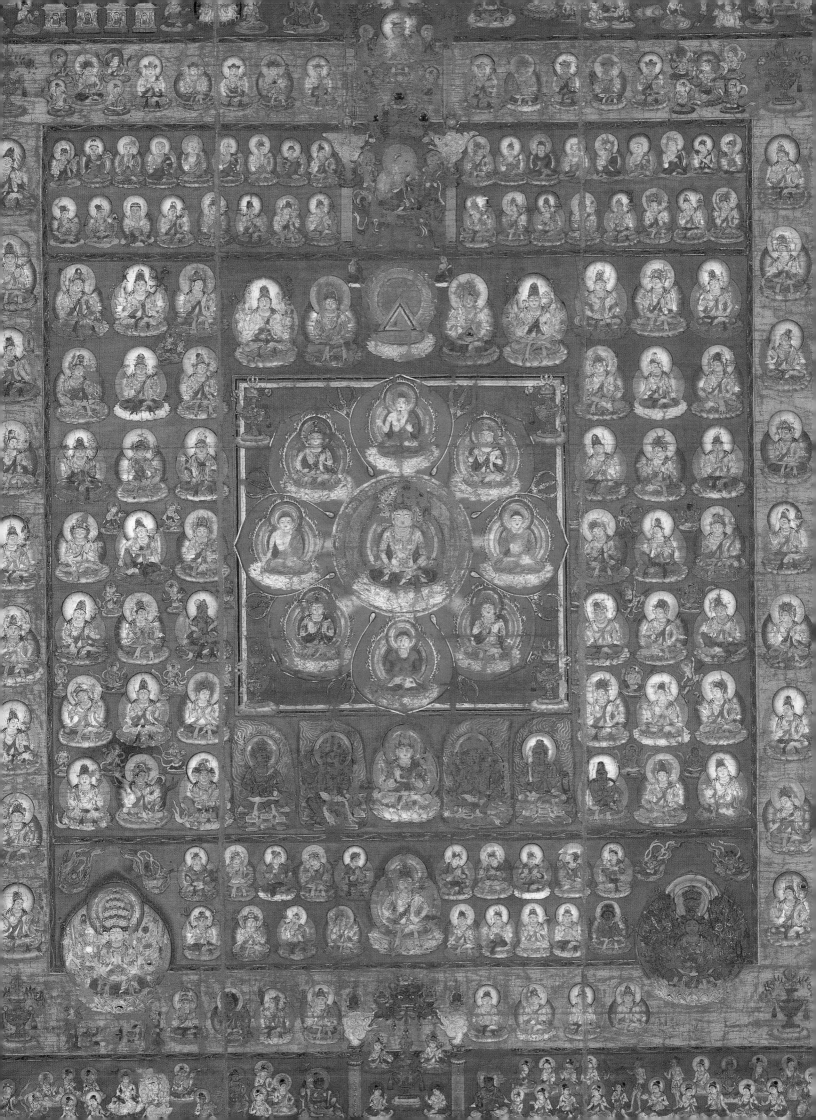

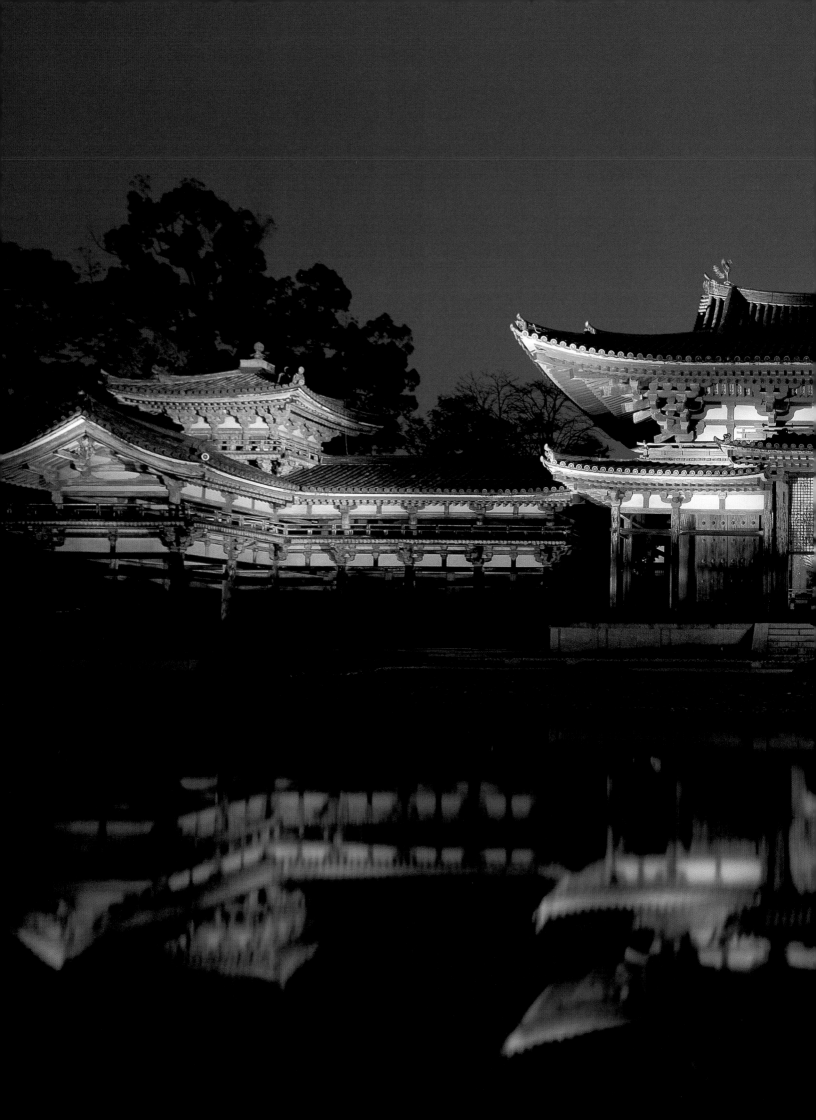

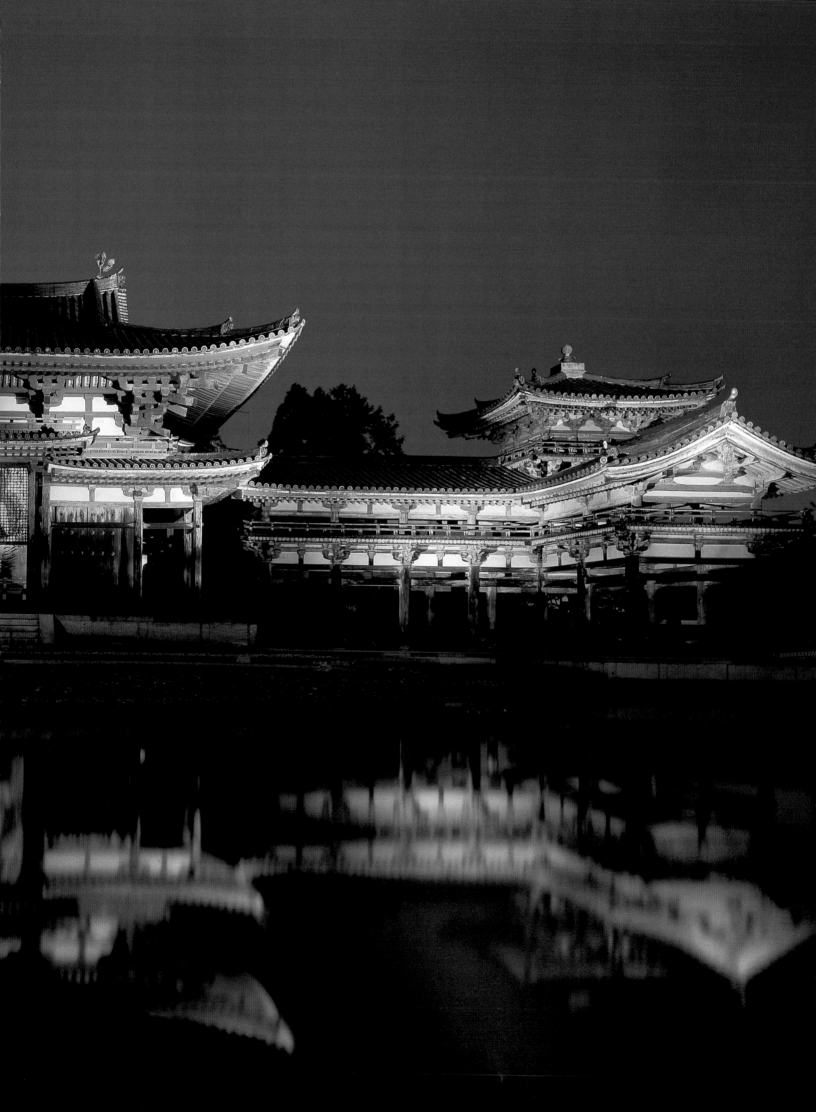

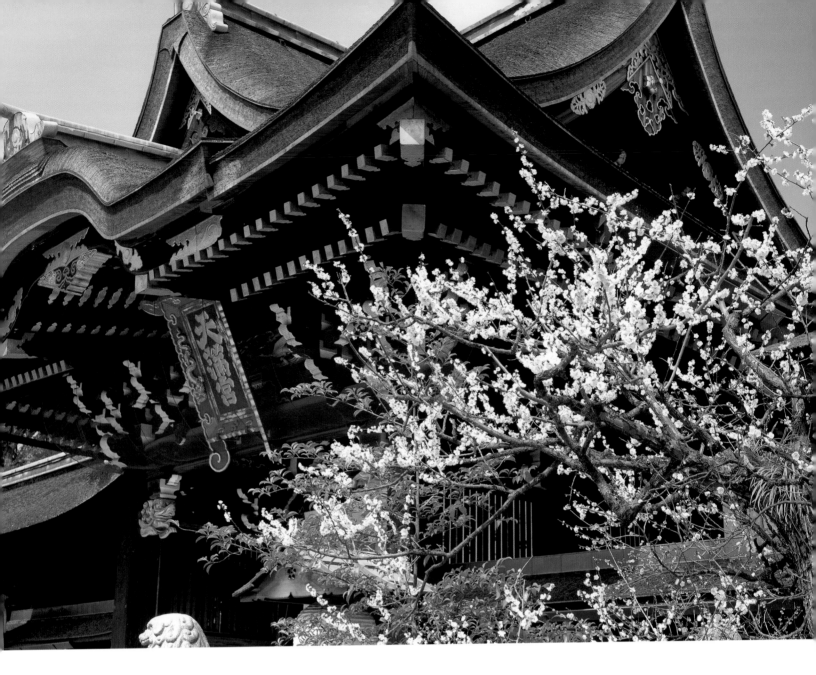

Michinaga is also remembered as the model for the main character of the *Tale of Genji*, the world's first great novel, written in *hiragana* by a noblewoman named Murasaki Shikibu (late tenth–early eleventh century). *Genji* is the apotheosis of Heian taste and elegance, devoted to the pursuit of beauty in all its forms. The story spans four generations and imparts a wealth of information about Heian life, including courtship rituals, annual rites and ceremonies, religious beliefs, and more. *Genji* in particular displays that heightened awareness of the fleeting nature of life and bittersweet appreciation of its inherently sad beauty (*mono no aware*) that was the hallmark of Heian sensibility.

After Michinaga, the Fujiwara regency declined in power. To restore the imperial fortunes, an emperor elected to abdicate in favor of his small son, becoming a Buddhist priest—and continuing to wield power behind the scenes. This system of "cloister government" became institutionalized, with "retired" emperors wielding great power. Those locked out, however, were a perennial source of unrest.

In the provinces, meanwhile, a new class of warriors known as samurai was on the rise. As law and order broke down in the nation's capital, this military class was steadily pulled into factional struggles and attempted coups. Two warrior clans emerged as leading rivals, the Taira and the Minamoto. In the Heiji Disturbance

PREVIOUS PAGE: Phoenix Hall of the temple Byodo-in, Uji.

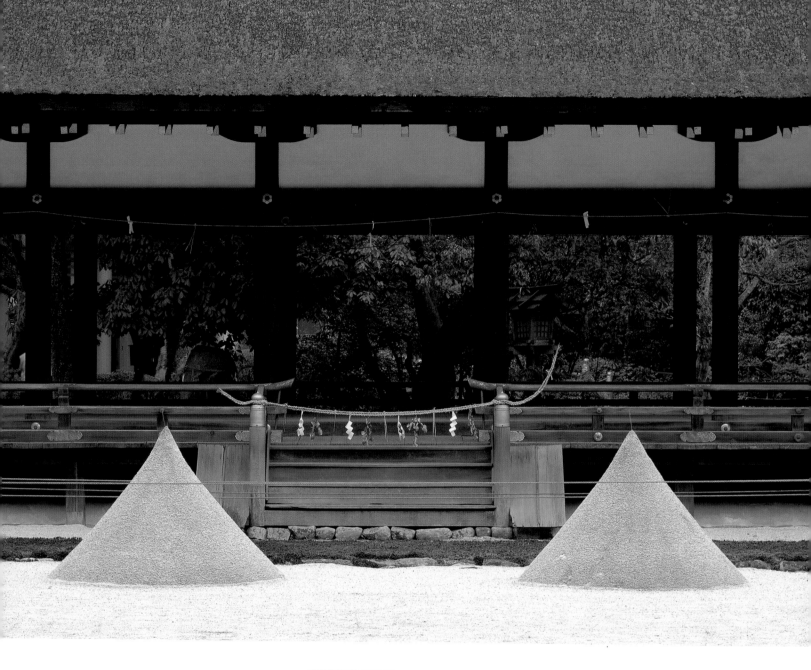

LEFT: Gate of the Three Luminaries, at the shrine Kitano Tenman-gu, with plum blossoms. **ABOVE:** Two sand cones in the shrine garden of Kamigamo. **RIGHT:** Vermillion shrine gate of Shimogamo.

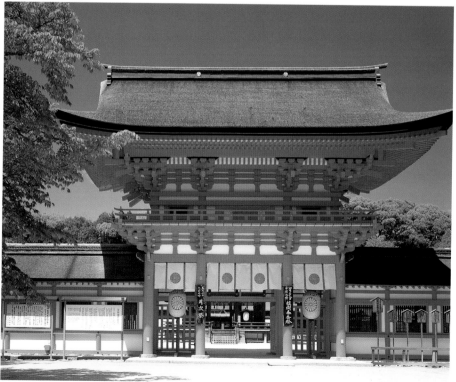

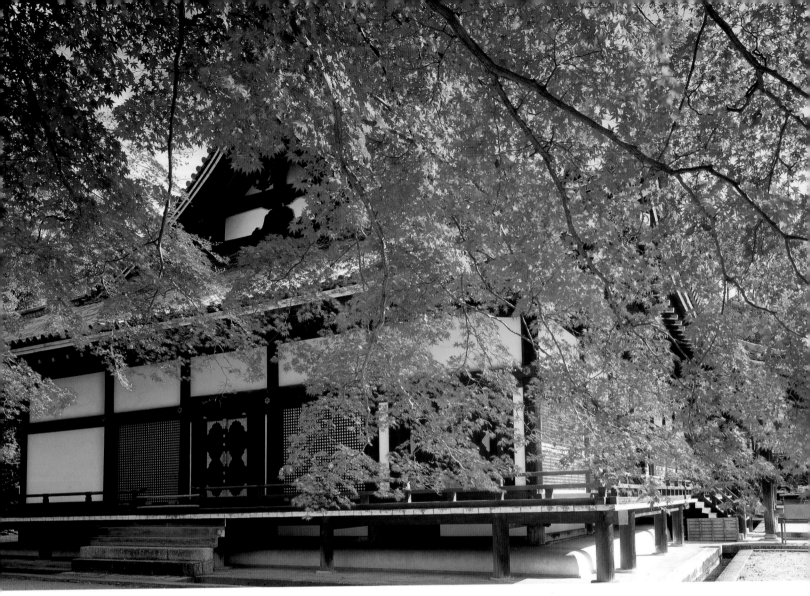

of 1160, Taira no Kiyomori (1118–81) crushed the Minamoto and went on to rule the court for twenty years. He lived just long enough to see his two-year-old grandson Antoku named emperor in 1180.

The tenor of the times had shifted to violence and despair. There was a pervasive sense of having entered what Buddhism called *mappo*, or "the latter days of the law," a degenerate age when the teachings of Buddha are ignored and society is in chaos. In this context, a succession of charismatic teachers offered hope through the saving grace of Amida Buddha, and Buddhism became a simple faith for the masses.

A Kyoto-centered movement founded by the priest Honen (1133–1212) stressed the path of *nenbutsu*, the invocation of Amida Buddha, in order to be reborn in the western Pure Land. Honen's disciple Shinran (1173–1262), founder of the Jodo Shin sect of Pure Land Buddhism, made faith, conferred upon the individual by the grace of Amida Buddha, the sole precondition for attaining rebirth in the Pure Land. He famously proclaimed, "If even a good person will attain salvation, all the more so will an evil one!" During this age of religious fervor, temple after temple was founded in Kyoto to carry on the teachings of spiritual leaders. Honen is associated with the temple Chion-in and Shinran with the rival temples Nishi Hongan-ji and Higashi Hongan-ji.

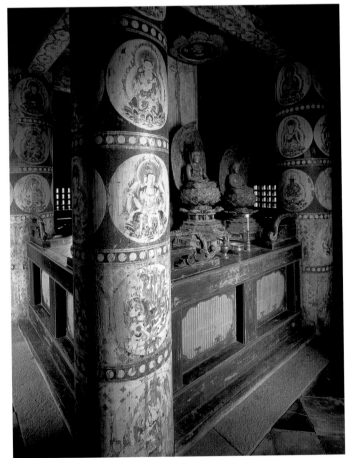

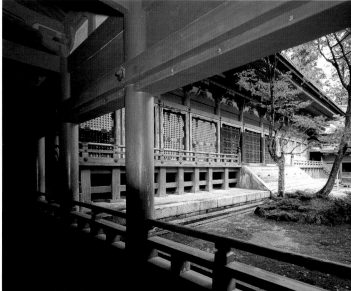

TOP LEFT: Golden Hall of the temple Ninna-ji, in autumn. **BOTTOM LEFT:** Interior of the five-story pagoda at Ninna-ji. **ABOVE LEFT:** A monk in traditional pilgrim garb performs *kaihogyo* (mountain training) on forested Mt. Hiei. **ABOVE RIGHT:** Exterior view of Konponchu-do hall, at the temple Enryaku-ji, Mt. Hiei. **BOTTOM RIGHT:** Konponchu-do hall as seen from a connecting corridor.

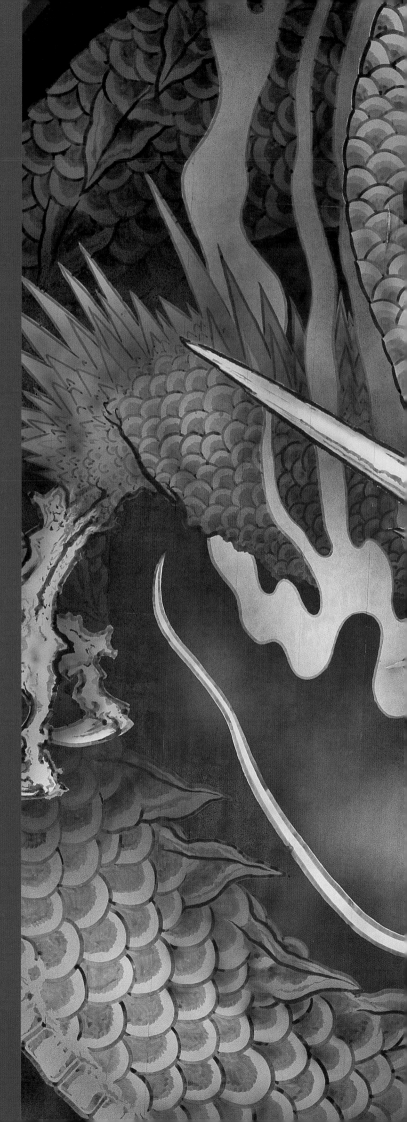

THE KAMAKURA AND MUROMACHI PERIODS
(1185–1573)

In 1185, the Taira suffered a crushing defeat in the Battle of Dan-noura, at the western end of the Inland Sea. The baby emperor Antoku was drowned; only his mother Kenreimon'in survived, to live out her days in prayer at Jakko-in, a nunnery north of Kyoto. These events are recorded in another important literary work, the *Tales of the Heike*, where the fall of the Taira symbolizes Buddhist teaching on impermanence.

After his victory, Minamoto no Yoritomo (1147–99) was given the title of shogun, or military dictator. He established the offices of a warrior government far to the east in Kamakura, with his rule extending west from Kyoto (Heiankyo's new name) all the way to Kyushu. Thus began Japan's medieval period, during which a succession of samurai families would continue to rule the country under the shogun system for some seven centuries, until 1868.

In 1191 a new chapter in Japan's religious history began as the priest Eisai (1141–1215) returned from China and founded the Rinzai sect of Zen Buddhism. Zen took hold first in Kamakura, but eventually such Kyoto monasteries as Daitoku-ji, Nanzen-ji, and Tenryu-ji became vital centers of medieval Japanese culture. The Gozan (Five Temples; literally "five mountains") monasteries in Kamakura and Kyoto were the most important of hundreds of officially sponsored Zen temples established around the country in the fourteenth and fifteenth centuries.

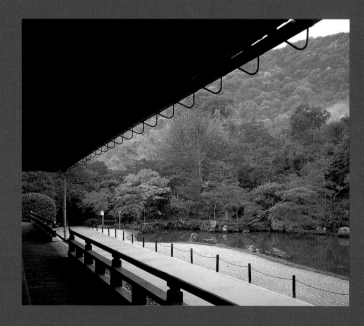

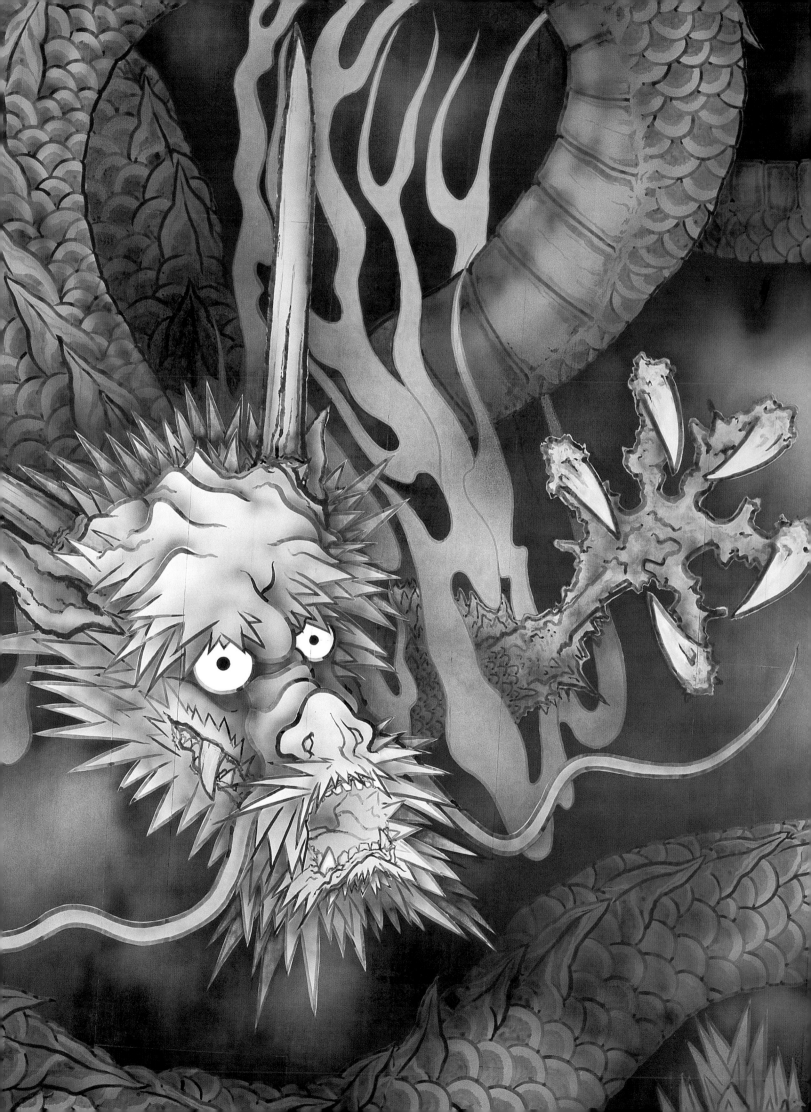

The garden of the temple Ryoan-ji (see pages 10 and 32), dated 1450, exemplifies the austere refinement and economy of expression associated with Zen. Done in *karesansui*, or "dry landscape" style, the rectangular, wall-enclosed garden consists of fifteen irregularly shaped stones, arranged singly and in clusters on a bed of white sand that is raked every day. The minimalist, abstract quality of this and other such gardens suggests a universe in miniature. It is easy to lose oneself in the swirl of sand or gravel and the contrast of shapes and textures, and embark on a journey of quiet contemplation.

Relations with the mainland took a disquieting turn after Mongol barbarians rose to power in China and their leader, Khubilai Khan (1215–94), turned his sights on Japan. Alarm swept Kamakura and Kyoto alike as threatening missives were followed by actual attacks—first in 1274 and again, with greater menace, in 1281. Japan was saved from conquest by a timely pair of typhoons known to history as *kamikaze*, or "divine winds."

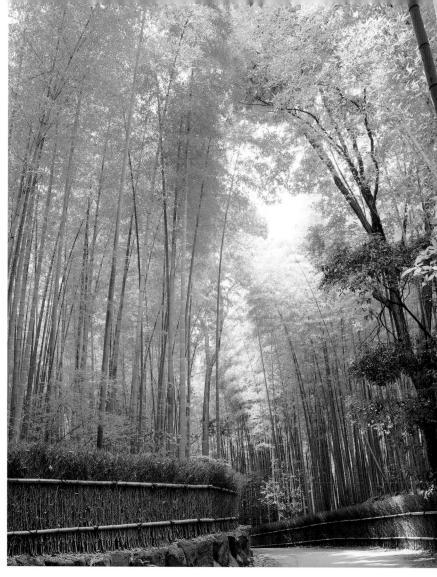

RIGHT: A bamboo grove in the Sagano district of Kyoto. **BELOW:** Firelight No performance at the shrine Heian Jingu. **FAR RIGHT:** The temple Kinkaku-ji in the snow.

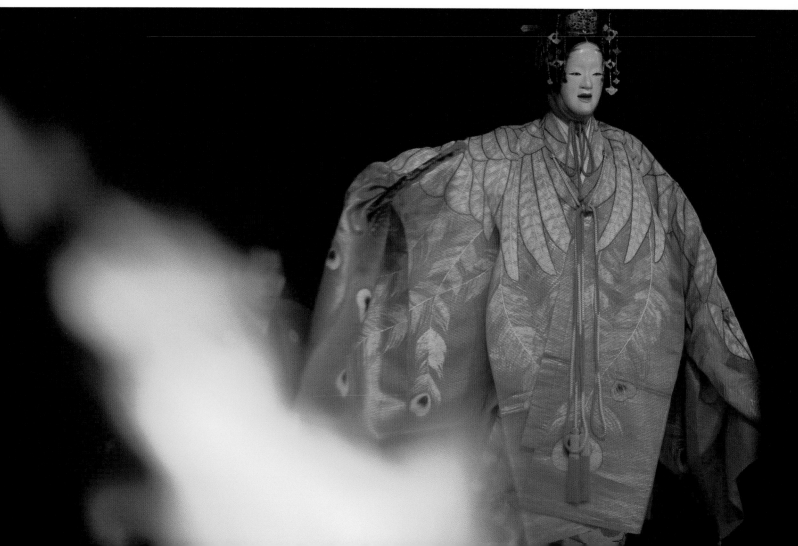

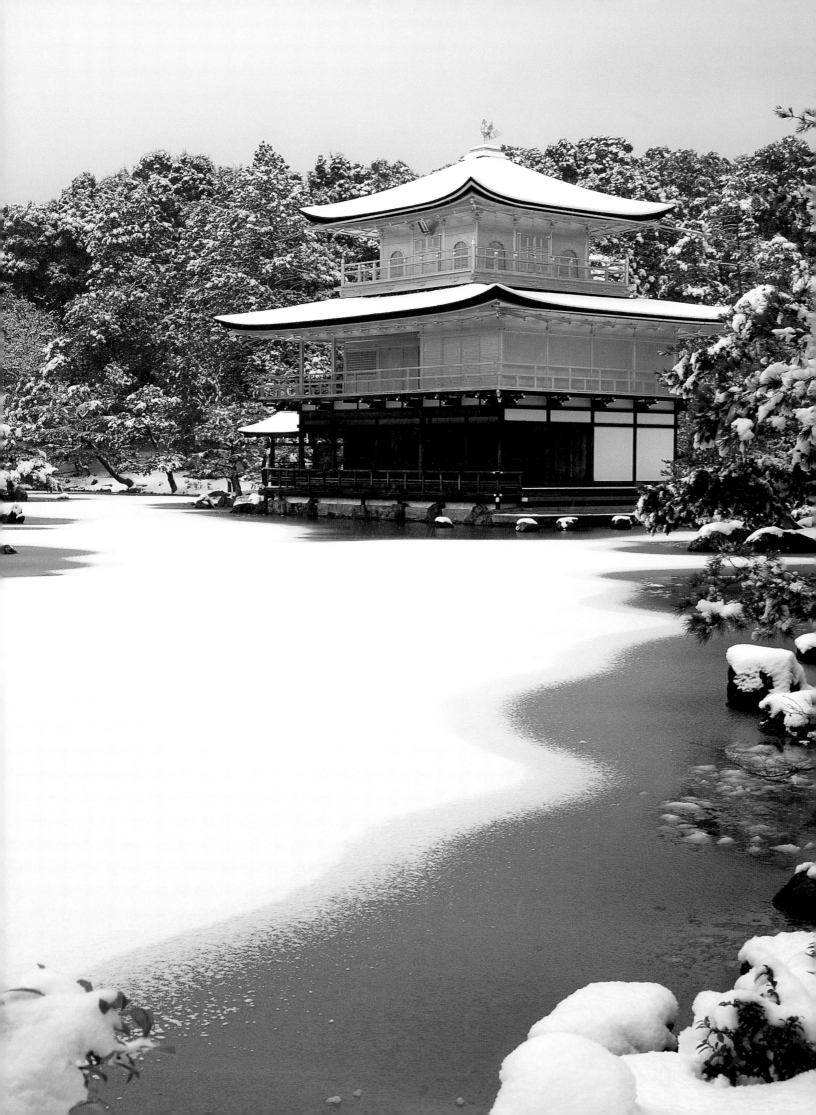

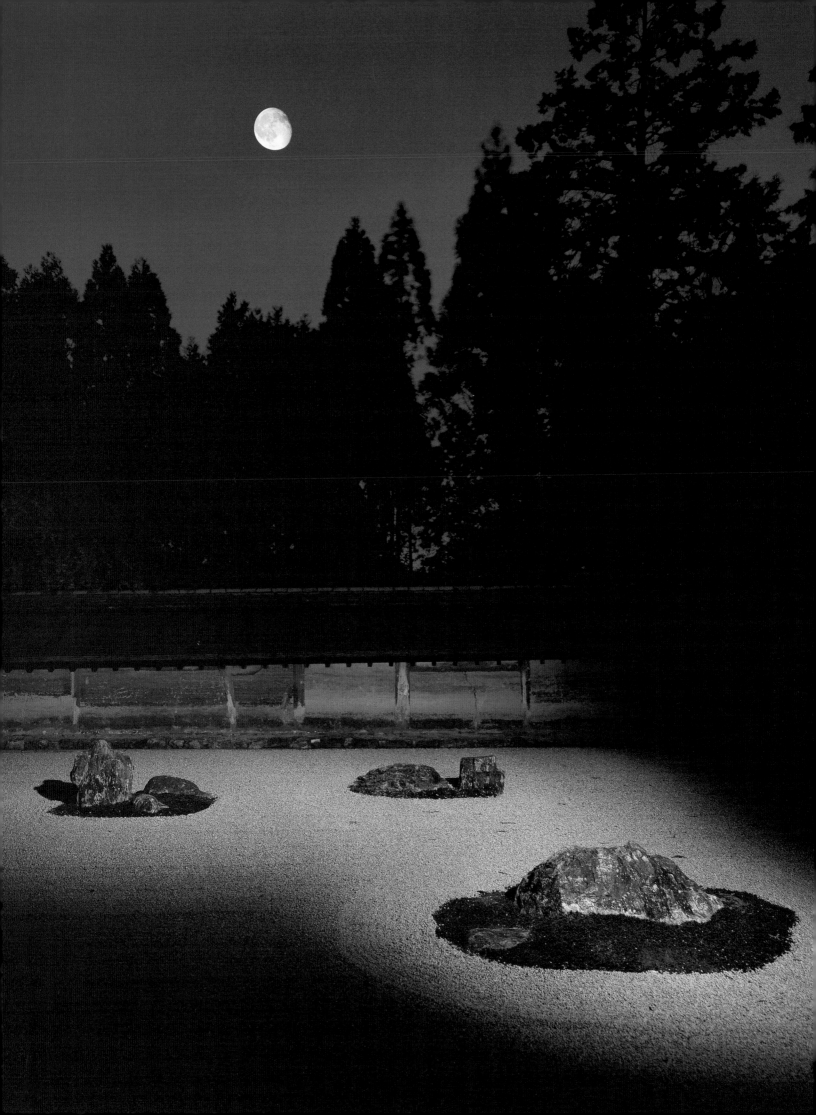

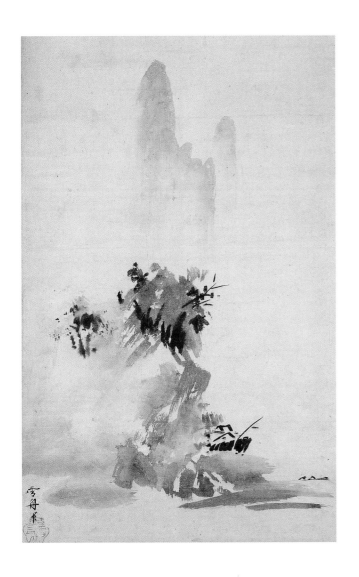

The Kamakura period ended with yet more strife. Determined to restore imperial rule, Emperor Go-Daigo (1288–1337) succeeded in ending the system of retired emperors and collapsing the Kamakura military government—but he could not prevent a takeover of power by his erstwhile ally, Ashikaga Takauji (1305–58). Chased southward to the mountains of Nara, Go-Daigo set up a rival court in Yoshino, creating a dispute over the imperial succession that lasted over fifty years.

The subsequent Muromachi period (1333–1573)—named for the quarter of Kyoto where the Ashikaga hegemons were established—was a time of widespread instability and chaos. Kyoto's fortunes revived, however, as the seat of government returned to the city. Warrior culture and aristocratic culture merged and fell under the influence of Zen Buddhism. Kyoto was again the political, spiritual, and cultural capital of Japan.

The Ashikaga shoguns generally neglected government and devoted themselves to lavish living. However, in 1392 Yoshimitsu (1358–1408), the third Ashikaga shogun, succeeded in mending the schism between the northern and southern courts. He retired three years later to the

Zen Buddhism flourishes. **FAR LEFT:** A temple garden in moonlight, Ryoan-ji. **TOP LEFT:** "Splashed ink" landscape painted by Sesshu in 1495. **BOTTOM LEFT:** Calligraphy by Zen monk Ikkyu (1394–1481): "Refrain from evil, carry out good." **BOTTOM RIGHT:** A temple priest of Myoshin-ji engaged in Zen meditation.

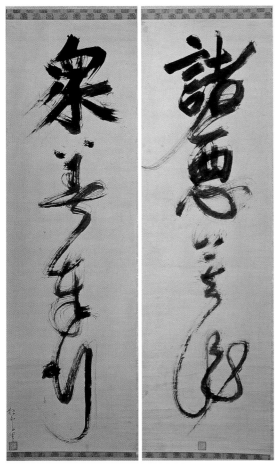

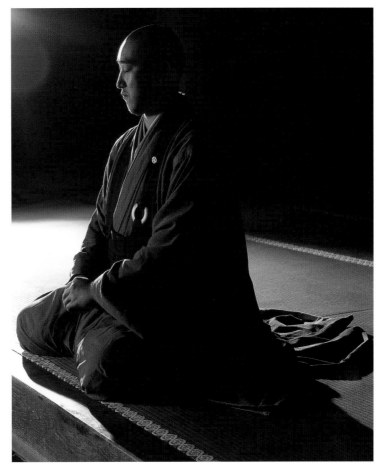

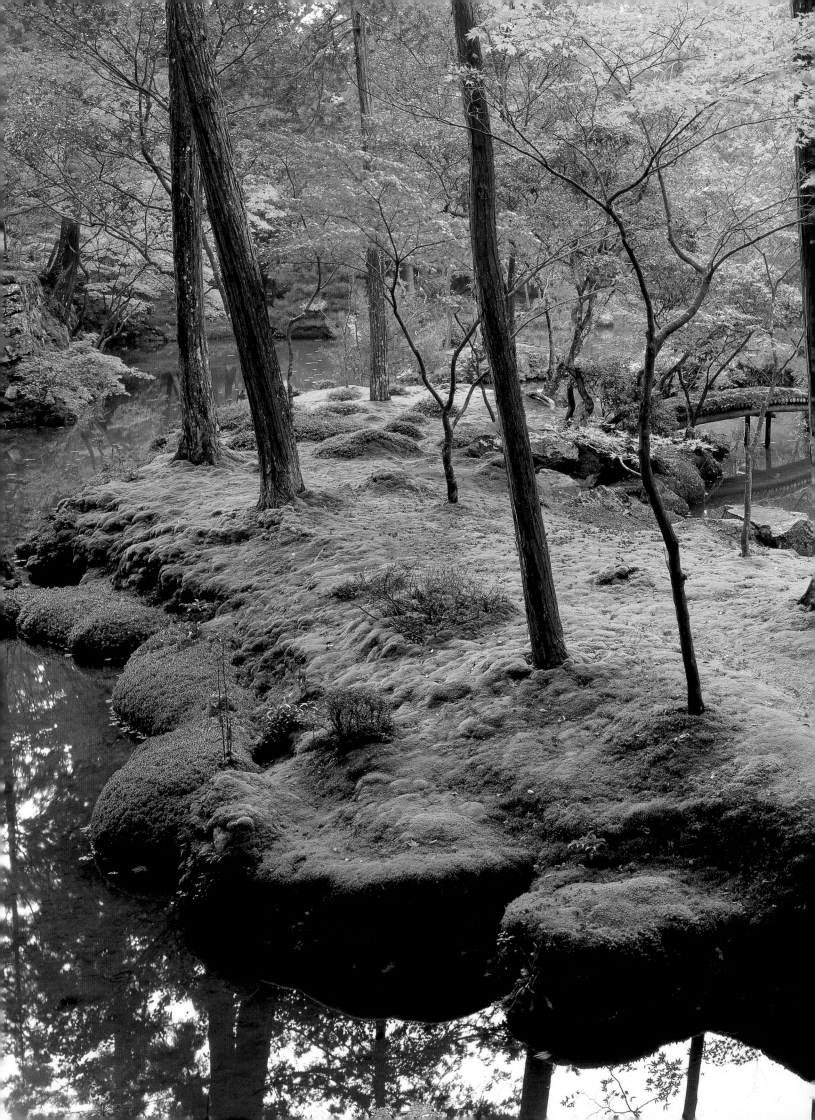

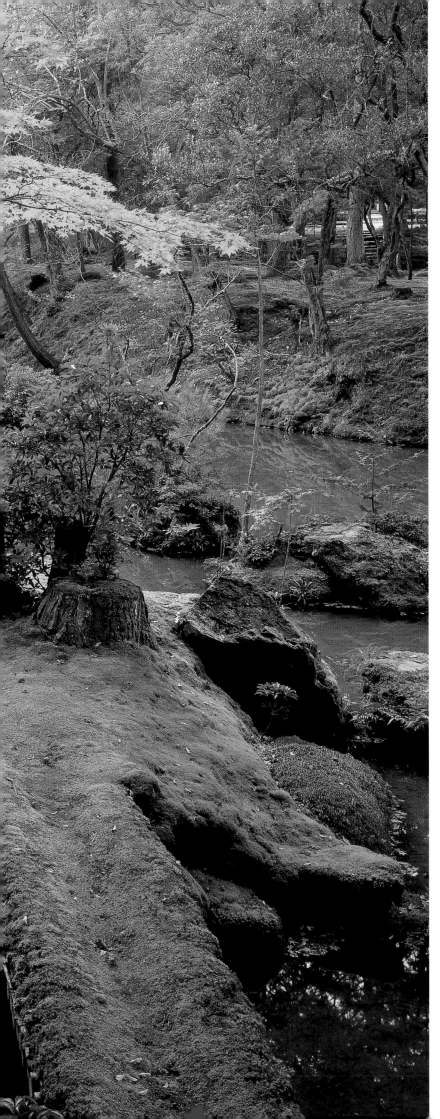

splendid Golden Pavilion (later Kinkaku-ji, page 31), set amid beautiful gardens by a pond at the foot of the Kitayama, the Northern Hills. The pavilion, said to be the first three-storied building in Japan, is so named because the second and third stories were covered in gold leaf within and without. Here Yoshimitsu continued to wield power, entertaining the emperor with performances of No drama created by his protégé, the brilliant Zeami (1363–1443). After Yoshimitsu's death the site became a Zen temple. The nation was shocked when on July 3, 1950, a temple acolyte burned the pavilion down in an act of senseless destruction; the incident inspired Mishima Yukio's novel *The Temple of the Golden Pavilion.* A replica was built in 1955.

Nearly a century after Yoshimitsu's time, the eighth Ashikaga shogun Yoshimasa (1436–90) completed a two-story counterpart to the Golden Pavilion, called the Silver Pavilion—even though it was never actually covered in silver. Despite the unending political and economic chaos of the times, for which Yoshimasa was in large part responsible, the culture reached its peak under his influence. Under Yoshimasa's unerring guidance, and informed by the pervasive spirit of Zen, the arts flourished as never before. The list of new or transformed arts is long: linked verse, calligraphy, monochrome ink painting, flower arrangement, bonsai, ceramics, lacquer work, and eclectic *shoin-zukuri* architecture. All assumed great importance. The first tea ceremonies were held in the Silver Pavilion, an architectural gem surrounded by gardens of raked sand and miniature landscapes. The landscape garden was refined to perfection and the magnificent No drama flourished, while the aesthetics of *wabi*, *sabi*, and *yugen* (emphasizing rusticity, understatement, and suggestion) became accepted as the highest ideals of artistic expression. This was a seminal period in Japanese literary, aesthetic, and cultural history.

Yoshimasa's retirement brought on yet another succession dispute that triggered bitter warfare, with fighting in the streets of the capital. Kyoto endured perhaps its darkest days in the Onin War of 1467–77, which nearly wiped out the city and brought on a near-century of nationwide chaos known as the Period of Warring States that lasted until 1568. Coincidentally, it was during this time of confusion that Japan had its first contact with the West as Portuguese traders came ashore and the Spanish missionary St. Francis Xavier (1506–52; born Francisco de Javier) arrived in Kyushu to spread the Christian gospel.

The moss garden at the temple Saiho-ji.

The garden of Sanbo-in (House of Three Treasures) at the temple Daigo-ji.

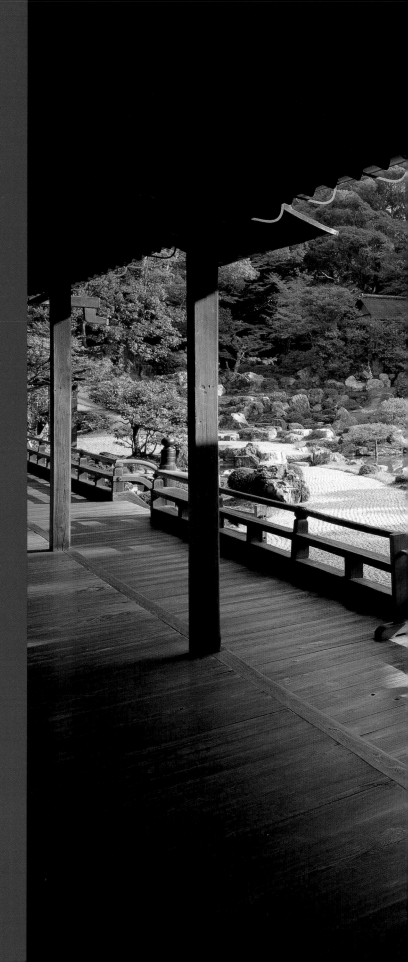

THE AZUCHI-MOMOYAMA PERIOD
(1568–1600)

Powerful warlords emerged to end the chaos engulfing Kyoto and the rest of the country and bring about national unification. The first of these, Oda Nobunaga (1534–82), swept into Kyoto in 1568. Ruthless in his determination, he burned the powerful Enryaku-ji monastic complex on Mt. Hiei in 1571 for having sheltered enemy troops. (The monastery recovered but would never again play any role in secular affairs.) Nobunaga was ultimately betrayed by one of his own men and ended up committing suicide in the Kyoto temple of Honno-ji. The residential castle he built in Azuchi, in present-day Shiga Prefecture, gives its name to what is known as the Azuchi-Momoyama period.

Toyotomi Hideyoshi (1536–98) continued the work of unification, also playing a big part in rebuilding Kyoto from the ashes and in promoting the arts. He is remembered for building Osaka Castle, as well as for the sword hunt he conducted in 1588, one purpose of which was to obtain metal to cast a huge Buddha for the temple Hoko-ji; the statue was unfortunately lost in an earthquake shortly after its completion.

It was also Hideyoshi who initiated a harsh crackdown against Christianity, beginning in 1589 with an edict proscribing the religion. This move was not prompted by religious intolerance so much as the desire to forestall Western meddling in Japanese internal affairs. Years before, St. Xavier had traveled from Kyushu all the way to Kyoto in hopes of winning an audience with the emperor, only to be denied. Still, Christianity did have an apparent impact in the capital; in 1576 a Jesuit church called Nanban-ji ("Southern Barbarian Temple") was built there—only to be destroyed a dozen years later on Hideyoshi's orders. A Western-style copper bell inscribed with the Jesuit logo and the year 1577, preserved in the temple Myoshin-ji, is likely a relic of that church.

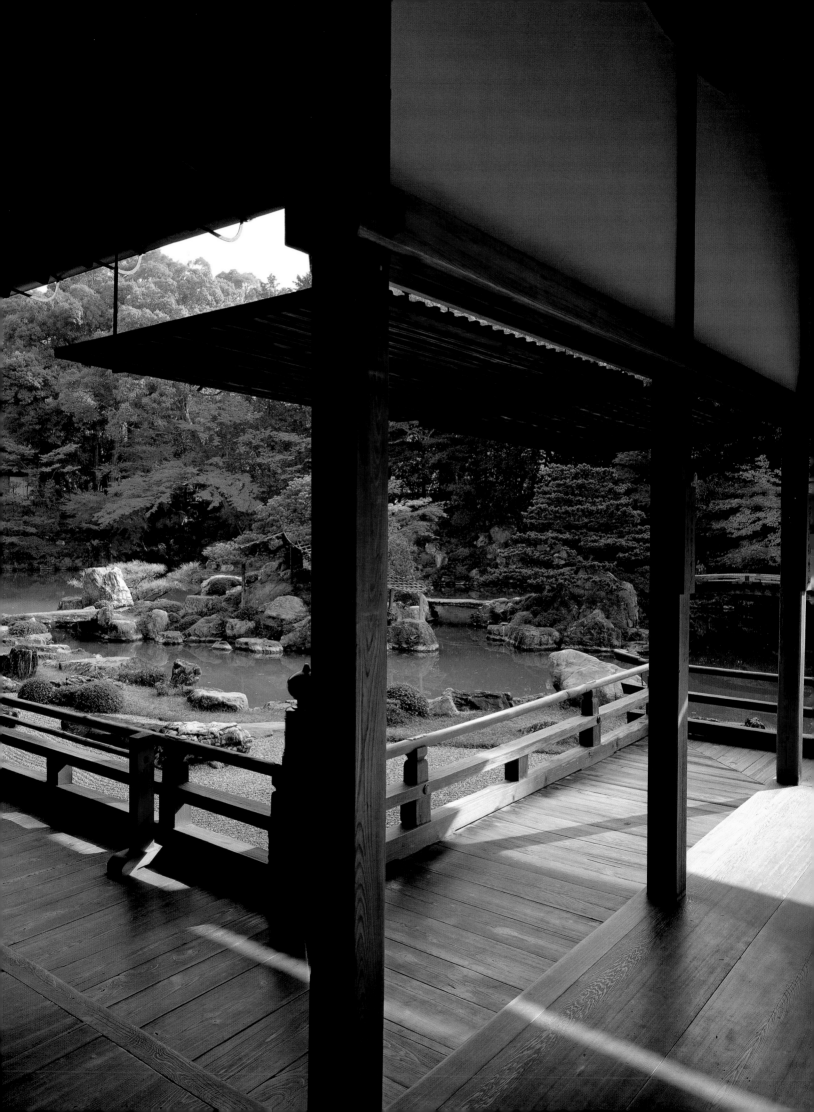

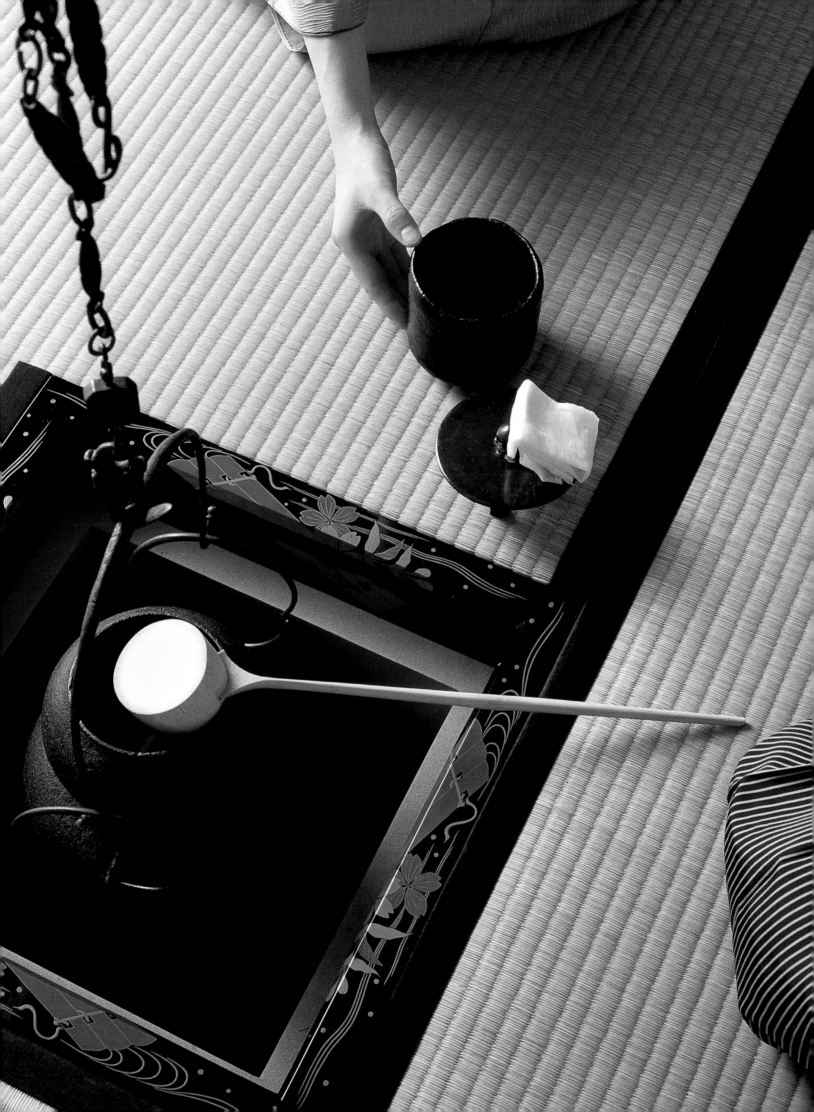

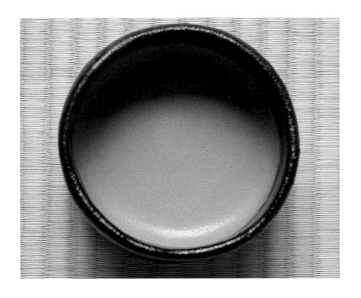

ABOVE: A bowl of *usucha*, one of the types of tea used in the tea ceremony. LEFT: Tea room interior with tea utensils at the inn Sumiya. BELOW: Flowers for the tea ceremony at a teahouse in Juko-in.

Hideyoshi is further associated with the tea ceremony as developed by the celebrated tea master Sen no Rikyu (1522–91), an important arbiter of sixteenth-century taste. In fact, the two men epitomize opposing traditions in Japanese taste, both of which were reinforced in this era: one an inclination toward the flamboyant and the opulent, the other a preference for the understated and the subdued. In 1587 Hideyoshi put up a gilded teahouse for a ten-day celebration at the shrine Kitano Tenman-gu (page 24), a lavish display that is echoed in the sumptuous, decorative painting of the era. Despite this tendency toward ostentation, Hideyoshi honored Rikyu and clearly appreciated his philosophy of simplicity and restraint, known as *wabicha*; inside the precincts of Osaka Castle he built a rustic hut for tea perfectly exemplifying that spirit.

Despite the favor he enjoyed, Rikyu somehow managed to earn Hideyoshi's wrath and was ordered to commit suicide. He did so in 1591 at Juko-in, in the temple complex of Daitoku-ji, where he is buried. His statue can be seen elsewhere on the temple grounds, along with a room of his Kyoto residence.

Hideyoshi became obsessed thereafter with annexing Korea, launching a pair of ill-starred invasions in 1592 and 1597. The scheme was dropped when he died in 1598. He was succeeded by Tokugawa Ieyasu (1542–1616), the last of the unifiers and the founder of the Tokugawa shogunate, which moved the center of the country's political power back east to Edo (now Tokyo).

OVERLEAF: Detail from a painted screen titled *Genre Scenes in Kyoto* (Funaki version), depicting seventeenth-century Kyoto.

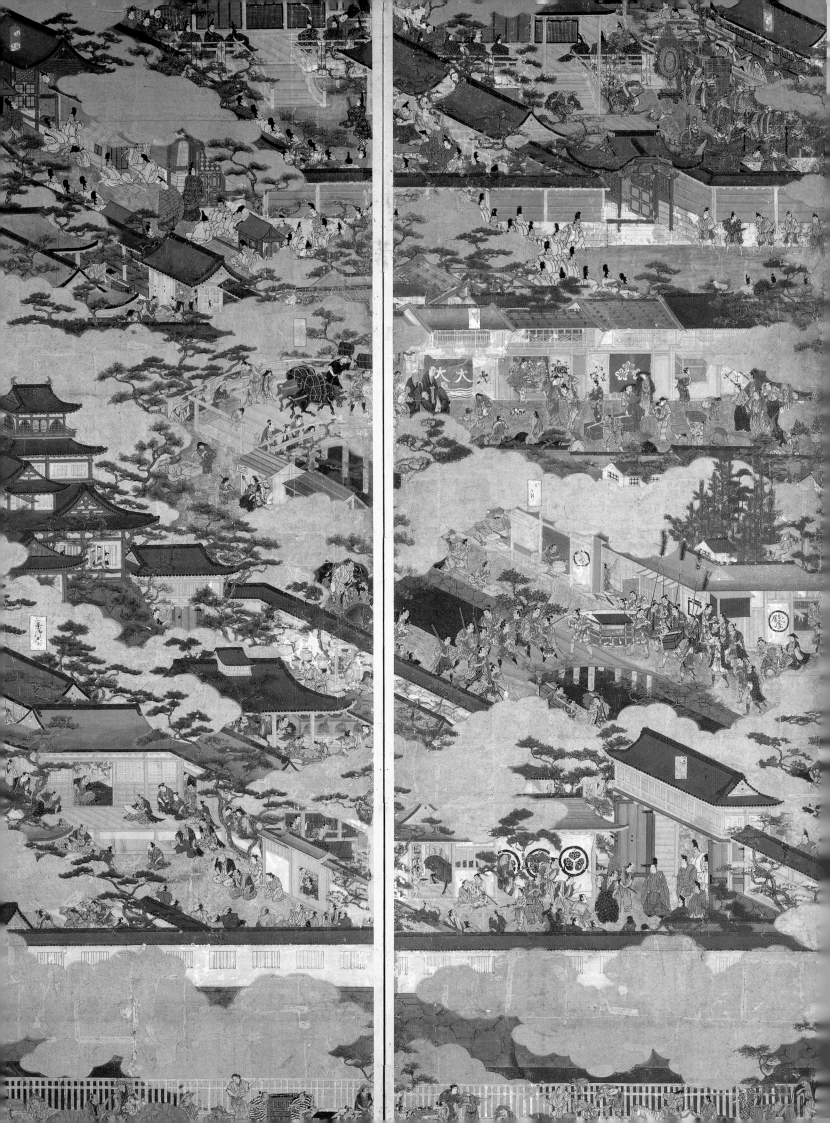

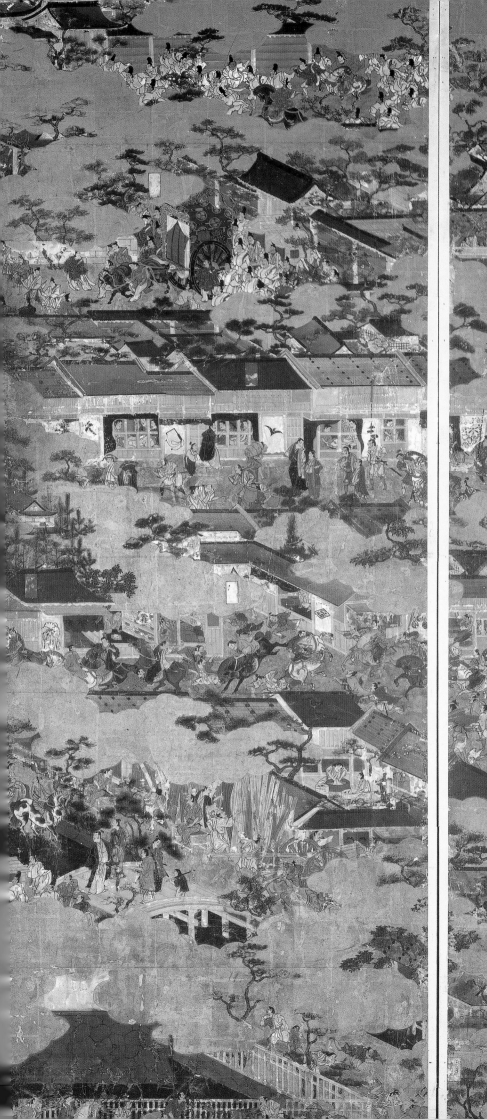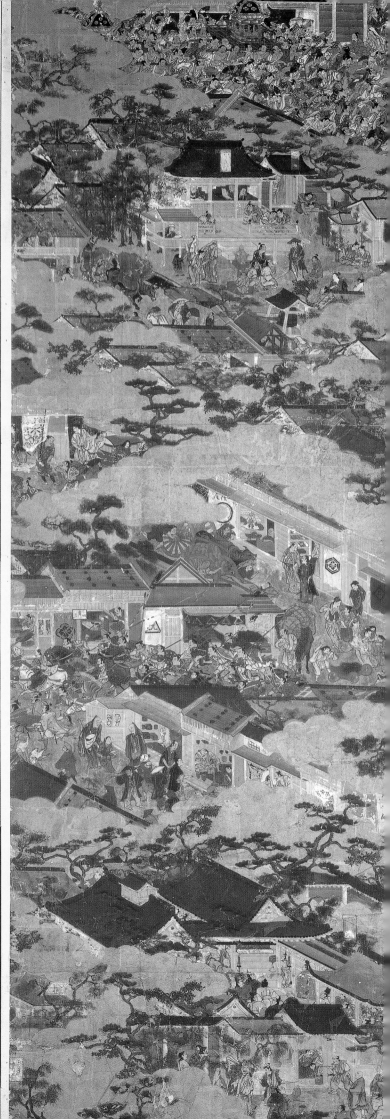

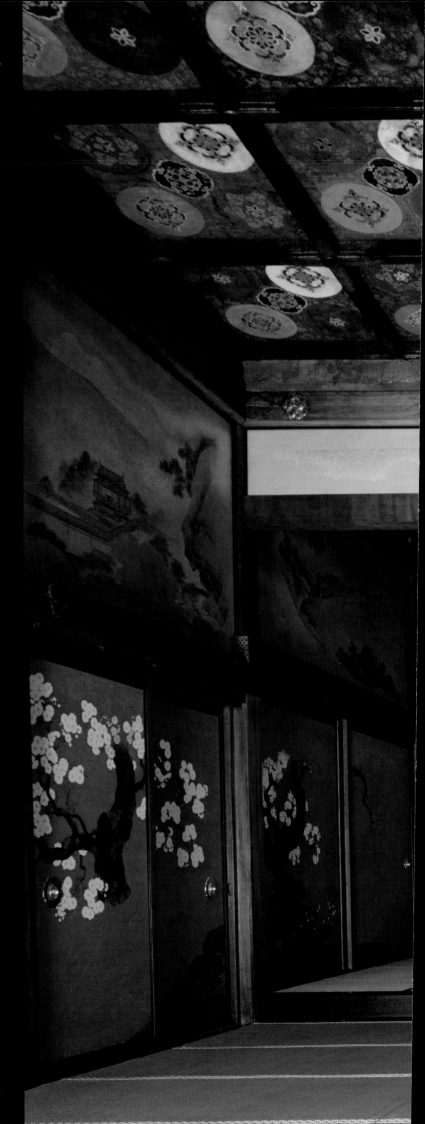

THE EDO PERIOD
(1603–1868)

The great legacy of Ieyasu in Kyoto is the imposing Nijo Castle he built in the heart of the city as his residence; here, in 1603, the emperor bestowed on him the title of shogun. The main court was destroyed by fire in 1788, and the only original part now remaining is the Ninomaru Palace second court. More like an elegant residential palace than a fortification, the castle blends in well with the urban landscape and has come to symbolize Kyoto culture. Its gardens and sumptuous interior bespeak the confidence and power of a man who expects his rule to last—as the Tokugawa shogunate indeed did.

Ieyasu's power was cemented in 1600 at the Battle of Sekigahara (between Kyoto and Nagoya). A few years later, a final rebellion of Japanese Christians in Kyushu ended with the slaughter of some 37,000 unfortunates. After that, the country entered at long last a time of prolonged peace and prosperity. The Tokugawa shogunate endured for two and a half centuries under a policy of national seclusion, where contact with the outside world was restricted to a handful of emissaries; then, in 1853, the arrival of Commodore Perry's American flotilla of "black ships" set events in

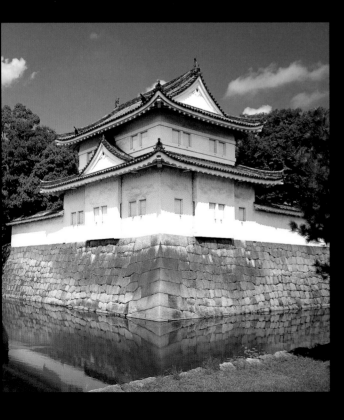

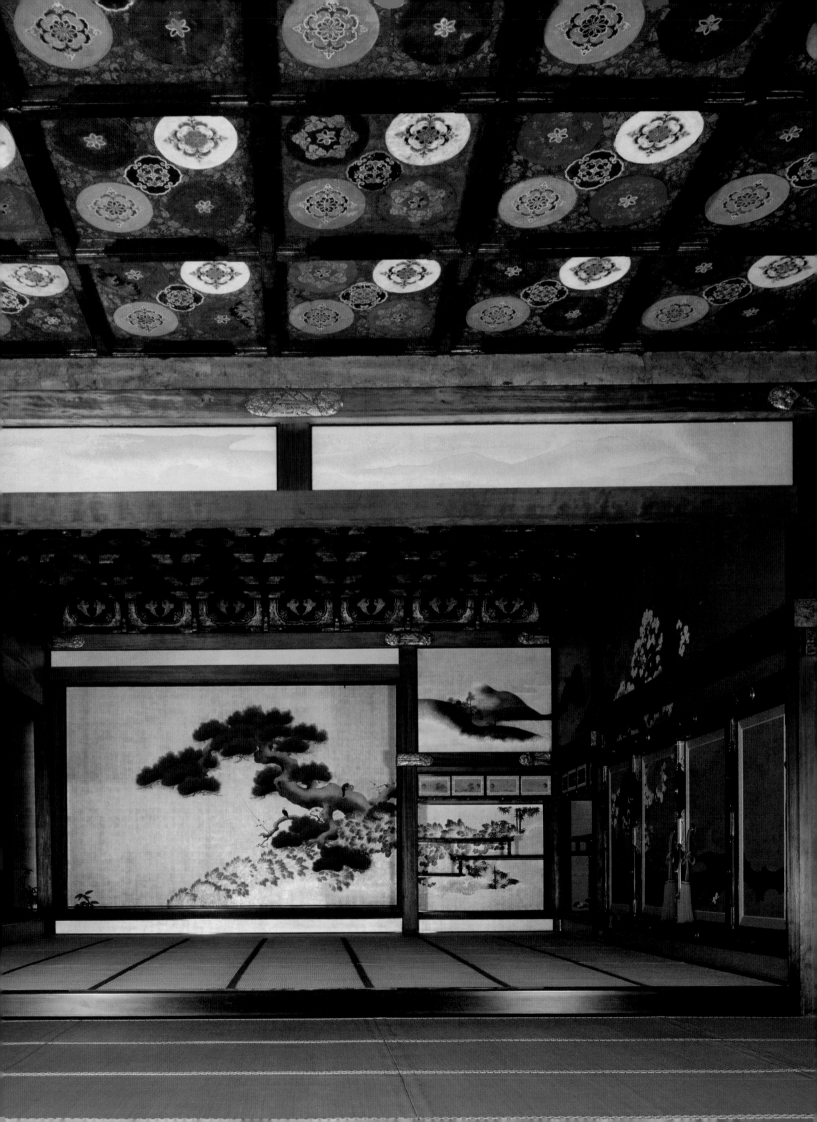

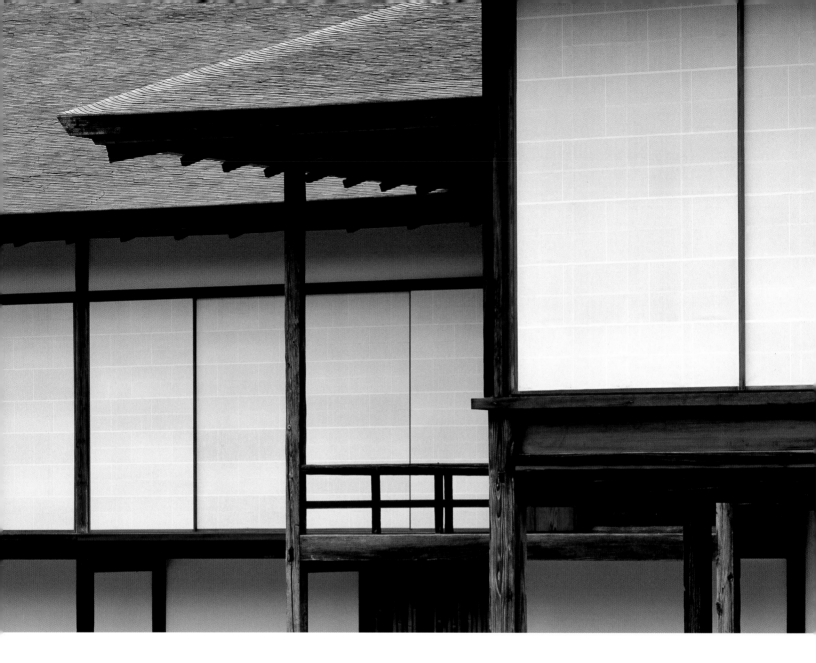

motion that would bring the era to a close. Loyalists virulently opposed to foreign intrusion and determined to "restore" power to the throne became increasingly hostile to the shogunate. In 1867, unable to resist the tide of change, the fifteenth and final Tokugawa shogun surrendered the powers of government in Nijo Castle, thus making way for the powers of modernization to work their will.

During the Edo period, Kyoto continued its prominent role in the development of Japanese culture. The city became known for a wealth of traditional crafts, including doll-making, bamboo crafts, fan-painting, incense, ceramics, lacquerware, kimono-dyeing, hair combs and ornamental hairpins, paper umbrellas, and weaving from the Nishijin quarter. To this day, other cities around the country with their own craft traditions are known as "little Kyotos," and Kyoto crafts often add the prefix "*Kyo*" to a product as a mark of quality.

The Edo period is also notable for various forms of entertainment that developed in Kyoto. Kabuki theater arose during this period, beginning with comic sketches performed on the dry bed of the river Kamo by itinerant entertainers. By the golden age of the Genroku era (1688–1704), it had evolved into a robust, mature theater with permanent playhouses in Osaka and Edo, as well as the great Minami-za in Kyoto. In the seventeenth century, the Shimabara pleasure quarters took on an aura of glamor, the highest-ranked courtesans easily rivaling Kabuki stars in fame. Later, as the geisha system emerged, the Gion district (one of the centers of geisha teahouses) became an elegant and sophisticated center

Views of the Katsura Detached Palace. **ABOVE:** From the east garden of the middle study looking across the music room to the New Palace. **TOP RIGHT:** The Shokintei teahouse seen from the *suhama* ("sandy beach"). **BOTTOM RIGHT:** Interior of the Shokintei teahouse.

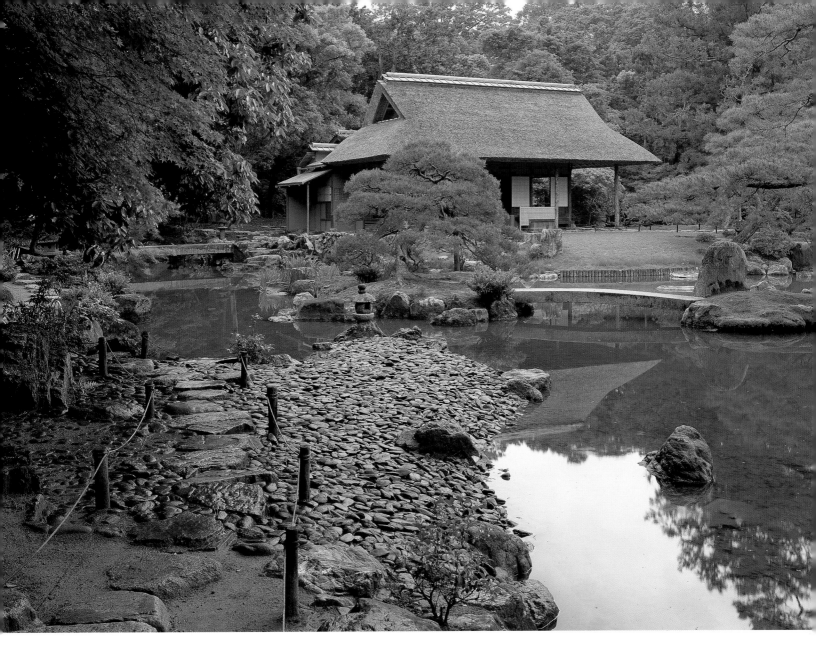

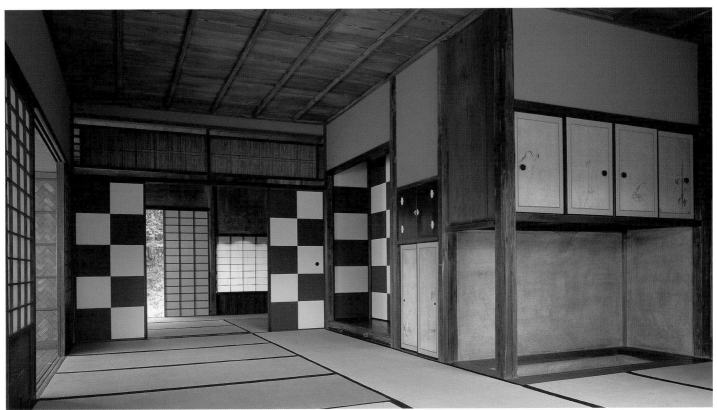

of urban culture that set standards in fashion and manners. Gion today remains a high-class entertainment center, as well as being the area of Kyoto that best preserves the atmosphere of bygone days.

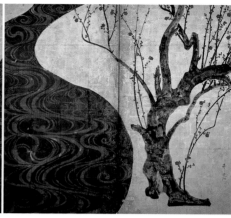

• • •

Ever since 1868, the emperor has lived in Tokyo. Even stripped of its original *raison d'etre*, Kyoto continues to thrive, still casting a spell on visitor and resident alike. The city has rich rewards for those who seek out its treasures. The high place Kyoto occupies in Japanese affections to this day, and the role it plays as an idealized space, are summed up in this haiku by master poet Matsuo Basho (1644–94):

> *Even in Kyoto*
> *I long for Kyoto,*
> *hearing the cuckoo sing.*

While the modern workaday world is always just around the corner, and can seem overwhelming in its insistence, Kyoto continues to beckon us to come and explore another world rich in history, nature, and beauty.

ABOVE: *Red and White Plum Blossoms*, a pair of two-panel folding screens by Ogata Korin (1658–1716), color on gold foil over paper. **BELOW:** Detail of Korin's screen.

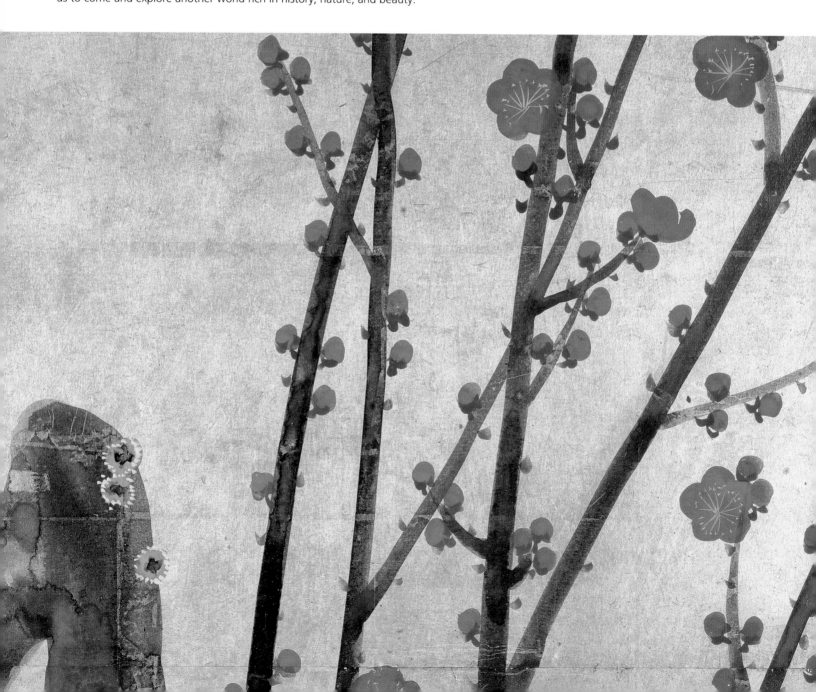

PART II

KYOTO CULTURE AND LIFE

To feel the allure of Kyoto culture may take time, but slowly it captivates you as you explore temples and shrines, stroll through cobblestone lanes and along riverbanks, and feast your eyes on exquisite gardens and green, encircling hills. The city and its culture speak to visitors in a hundred ways: the graceful sway of a *maiko*'s walk, the muted color and texture of a clay-wattled wall, the sight of a fan painter bent over his work. For all its newness and diversity, the city is steeped in ancient mysteries, still the Hana no Miyako, the Flowering Capital, of old.

Inuyarai, a protective barrier made of curved bamboo fronting a traditional Kyoto home.

OVERLEAF: Miyako Odori (Cherry Blossom Dance) performed by apprentice and full-fledged geisha.

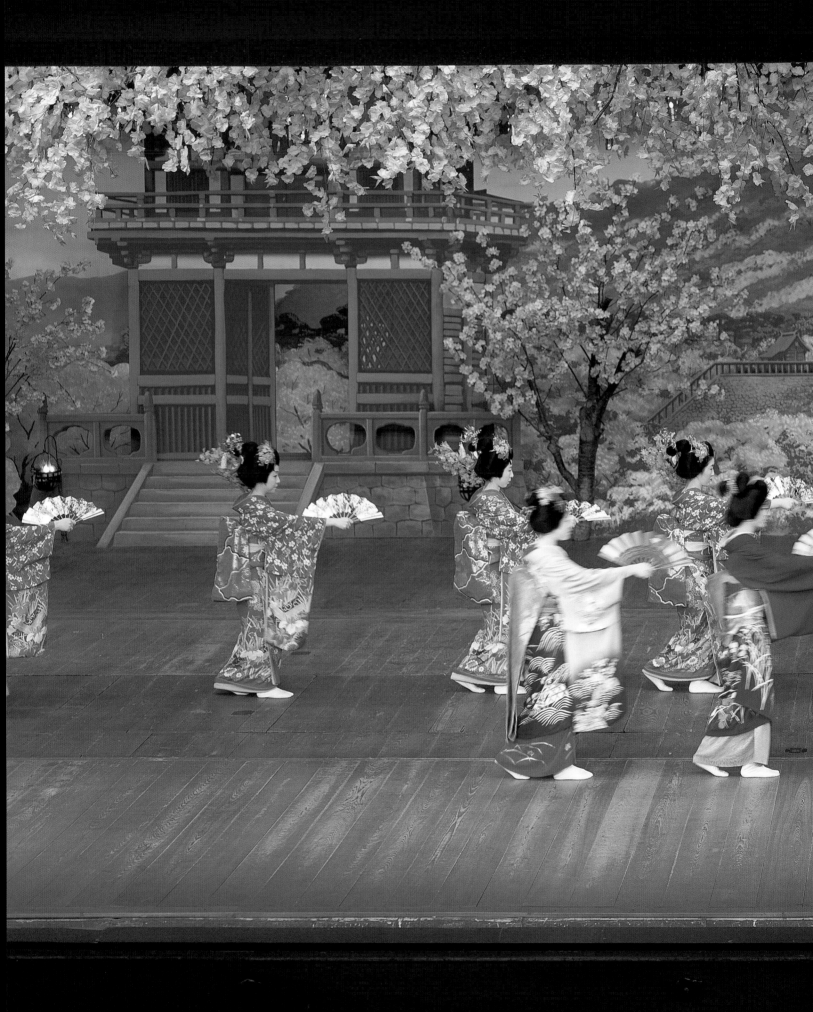

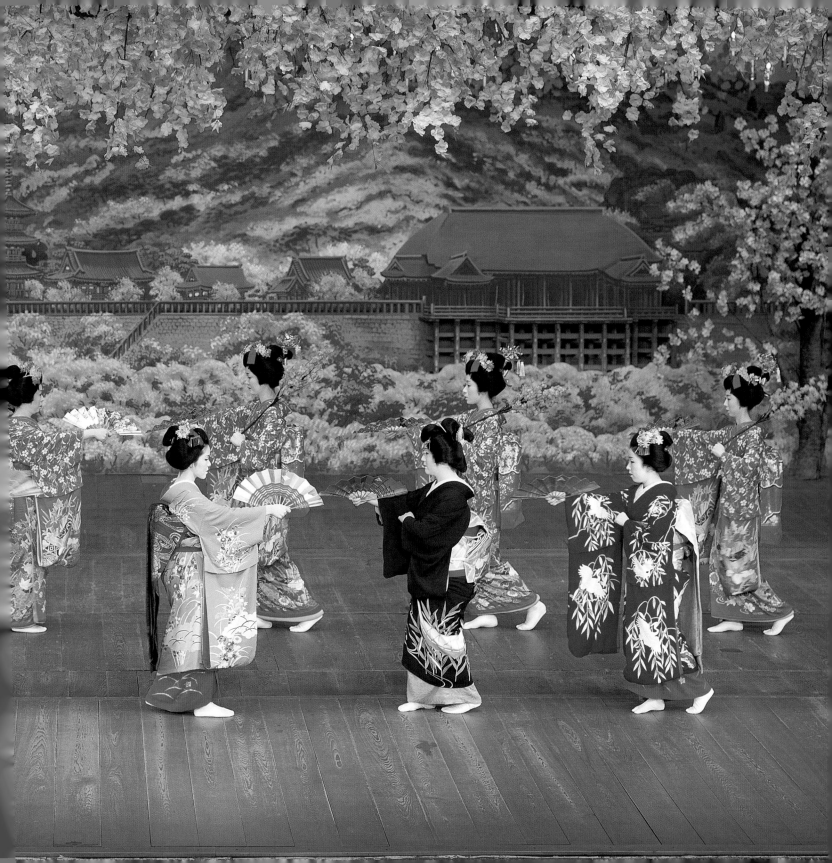

MAIKO

While strolling through the Gion section of Kyoto, the city's most famous geisha quarter, visitors may come upon the sight of young women wrapped in brightly colored silk kimono with long sleeves that fall nearly to their ankles, and wide-waisted sashes hanging down to the backs of their knees. On their feet they will be wearing high round clogs known as *pokkuri*, and their hair will be elaborately dressed in an old-fashioned style, with ornamental hairpins in the form of flowers. Known as *maiko* (literally, "dancing girls"), these elegant young women are apprentice geisha, probably on their way to a lesson in music or dance, or to an evening engagement.

A *maiko* wears distinctive makeup consisting of white powder and bright scarlet lipstick. A thick coating of powder is applied all over the face and neck, extending even to the back. Putting on the makeup, and then adjusting the wig, takes about half an hour. After that, a special male assistant comes to help the *maiko* into her kimono.

Traditionally, girls were apprenticed as *maiko* in their early teens, often sold from poor families who could no longer afford to feed them. Today, they generally begin their apprenticeship at a later age, and certainly no one is forced into the profession: all who take it up now do so by choice. As a professional entertainer, the geisha lives fully up to her name, the meaning of which is "artist." She dedicates her life to excellence in such traditional arts as the tea ceremony, classical dance, and the playing of drums, *shamisen* (a type of lute), and other traditional instruments. Moreover, she is expected to be a gifted and tireless conversationalist, both witty and discreet. Generally, about five years of hard training are required to become proficient enough for promotion to full-fledged geisha status—although, in a sense, the geisha's training never ends.

LEFT: An apprentice geisha seen through a lattice door. **ABOVE:** Plum blossom *hana-kanzashi*, a hair ornament worn by apprentice geisha. **BELOW:** Weeping cherry trees in the Gion district.

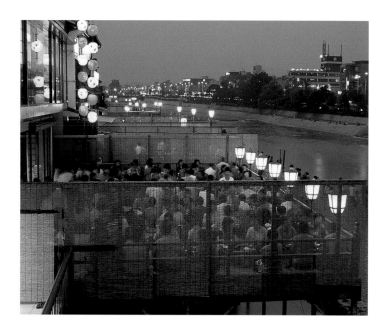

The history of geisha goes back some four centuries. While the earliest geisha entertainers were men, women soon took over the profession. A century ago geisha in Kyoto numbered in the thousands, but today there are only about a hundred working geisha. Mostly they perform at parties in special teahouses called *chaya*, closed to the general public; an evening's entertainment costs the equivalent of about a thousand dollars per guest. The *maiko* and geisha of Gion can also be seen performing traditional dances together as a group each spring and fall; the Miyako-odori, or Cherry Blossom Dance, in April is one of the city's biggest attractions.

ABOVE: Summer evening on a waterfront deck by the Kamo River, in Ponto-cho, across the river from Gion. BELOW: Apprentice geishas walking down a lane in Pontocho. RIGHT: Sunset over the Kamo River.

OVERLEAF: The weeping cherry tree of Maruyama Park at night.

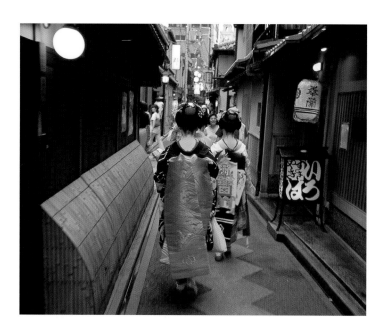

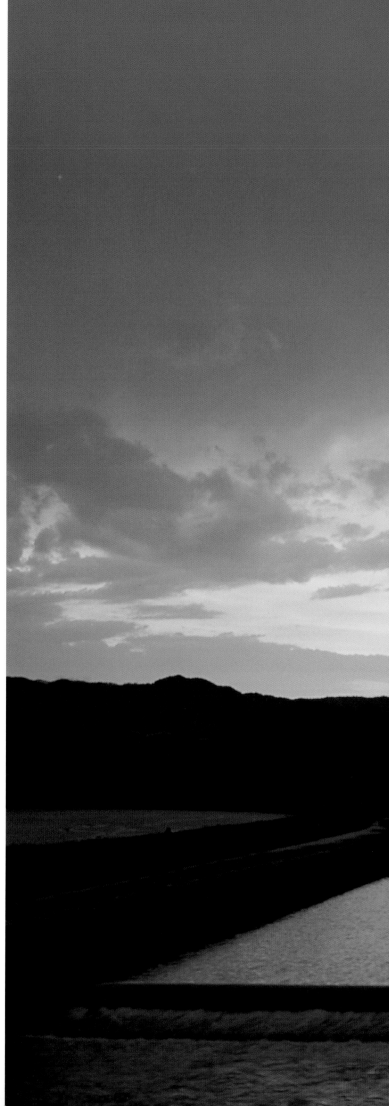

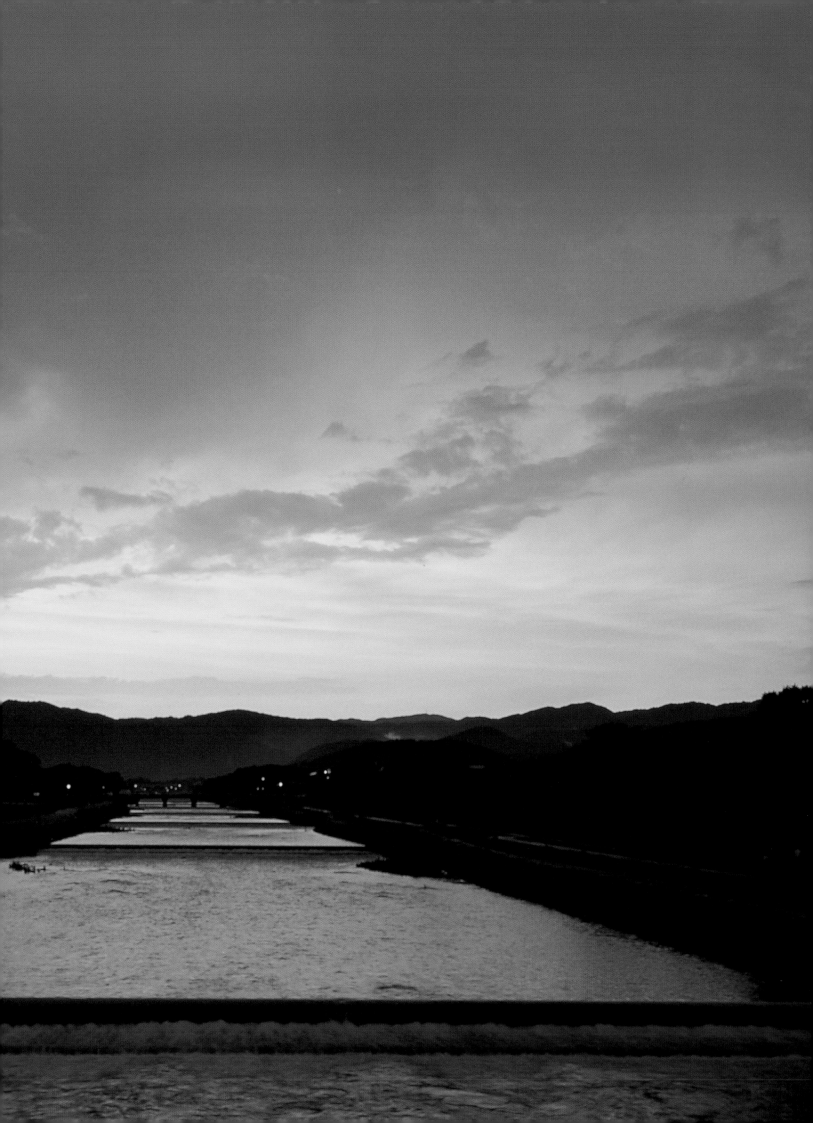

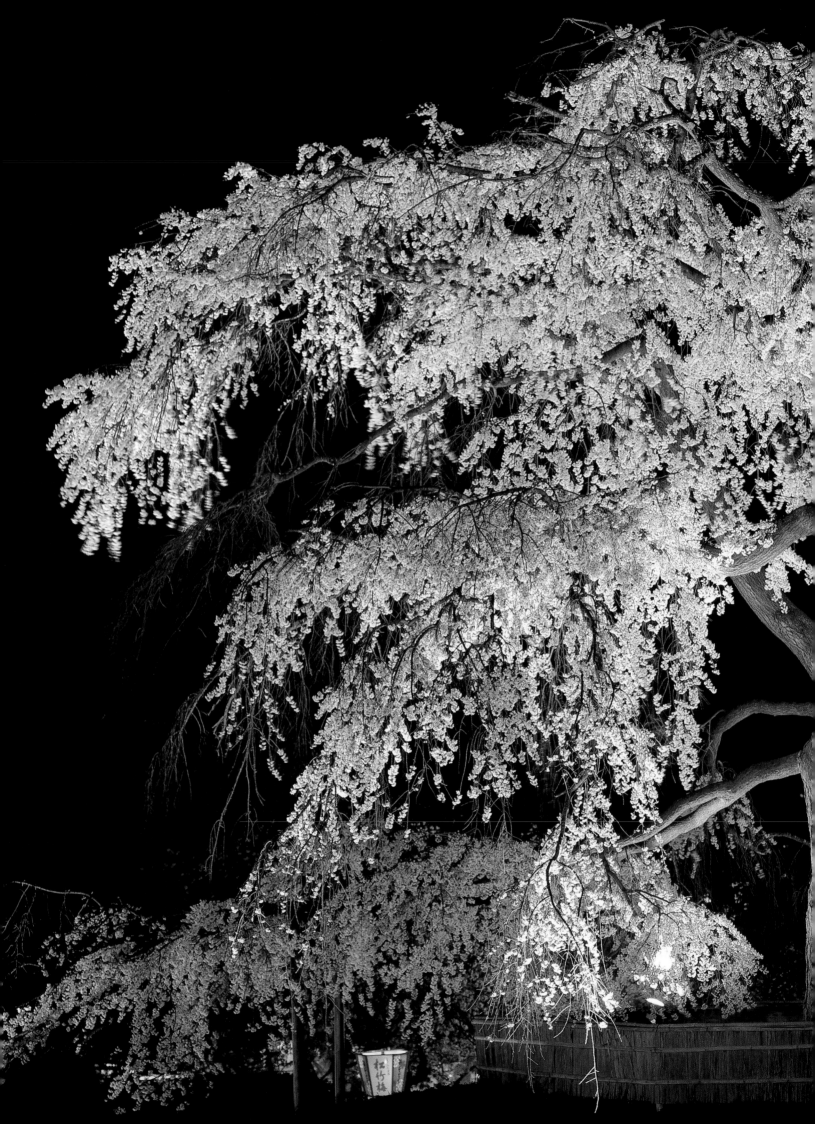

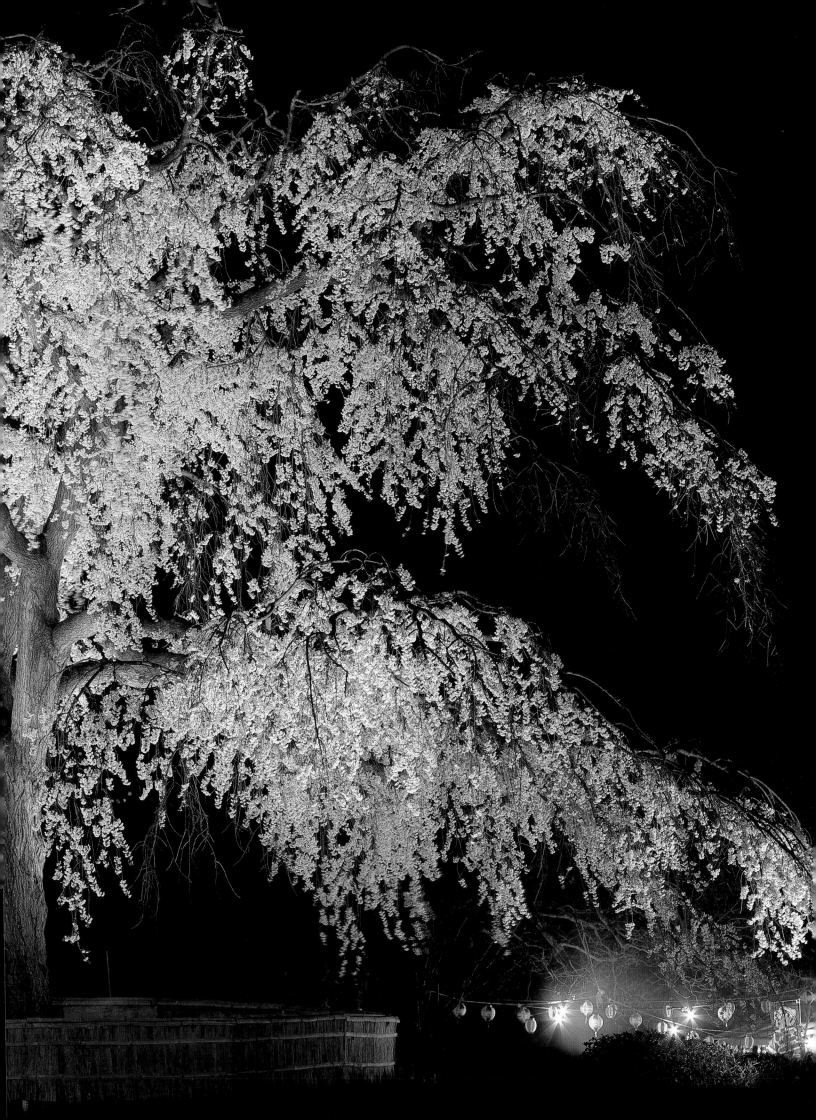

RIGHT: The Umbrella Room of Wachigaiya.
BELOW: Exterior view of Wachigaiya.

THE FLOATING WORLD

Shimabara, the old entertainment district of Kyoto, flourished during the Edo period. The licensed entertainment area was marked off by a moat and a gated wall just west of the temple Nishi Hongan-ji, not far from Kyoto Station. Inside, premiere geisha called *tayu* reigned in the legendary "floating world," in sumptuous houses that nurtured a distinct aesthetic and culture. The *tayu* were the highest-ranking geisha: beautiful women schooled in tea ceremony, music, and dancing, as well as the arts of conversation and hospitality. They were rigorously trained to be fit companions for their customers. Geisha are not to be confused with prostitutes; the demanding profession of entertainer was a lifelong one, and some women continued working to an advanced age.

Little remains today of the once-thriving district, which was eventually supplanted by Gion and Pontocho. Along with the historic gate, all that survive are one *okiya* (geisha residence) called Wachigaiya, and one *ageya* (elegant restaurant where *tayu* and geisha entertained) called Sumiya. Together, the two buildings represent a peak of grace and sophistication in Japanese residence architecture. Inside their walls a small number of *tayu* continue to perform the old traditional arts, providing a living link with Edo-period culture.

Like the traditional merchant townhouses of Kyoto called *machiya*, these handcrafted architectural masterpieces are low, two-story buildings with delicate wooden latticework on the exterior. From the outside, they have a plain and simple appearance that belies their richly decorative interiors. Inside, the rooms are cool, dark, and spacious, well suited to the climate, with elaborate carvings and richly painted walls and sliding doors. The Wachigaiya has a history of over three hundred years; the current building dates back to 1857, and the current owner represents the tenth continuous generation. The dimly lit rooms, some decorated with handwritten love letters from long ago, evoke a romantic atmosphere.

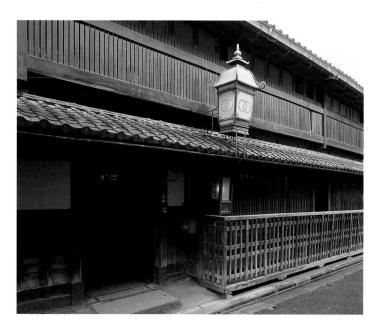

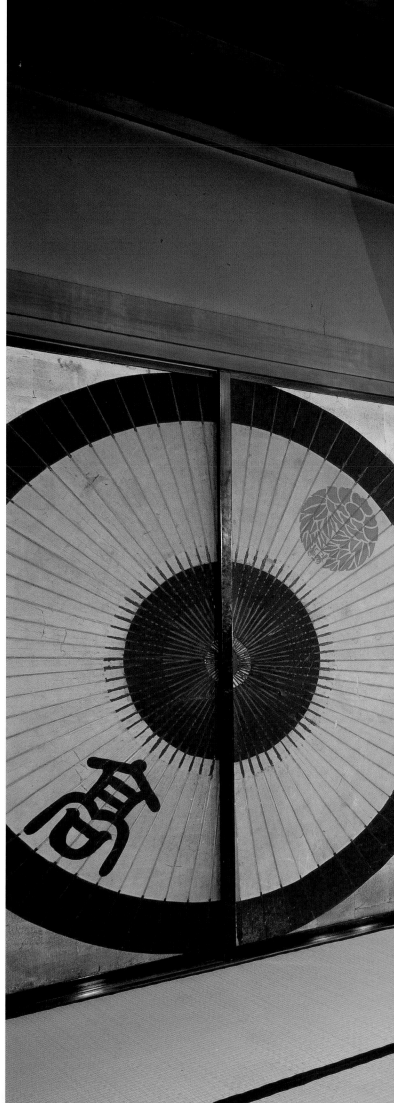

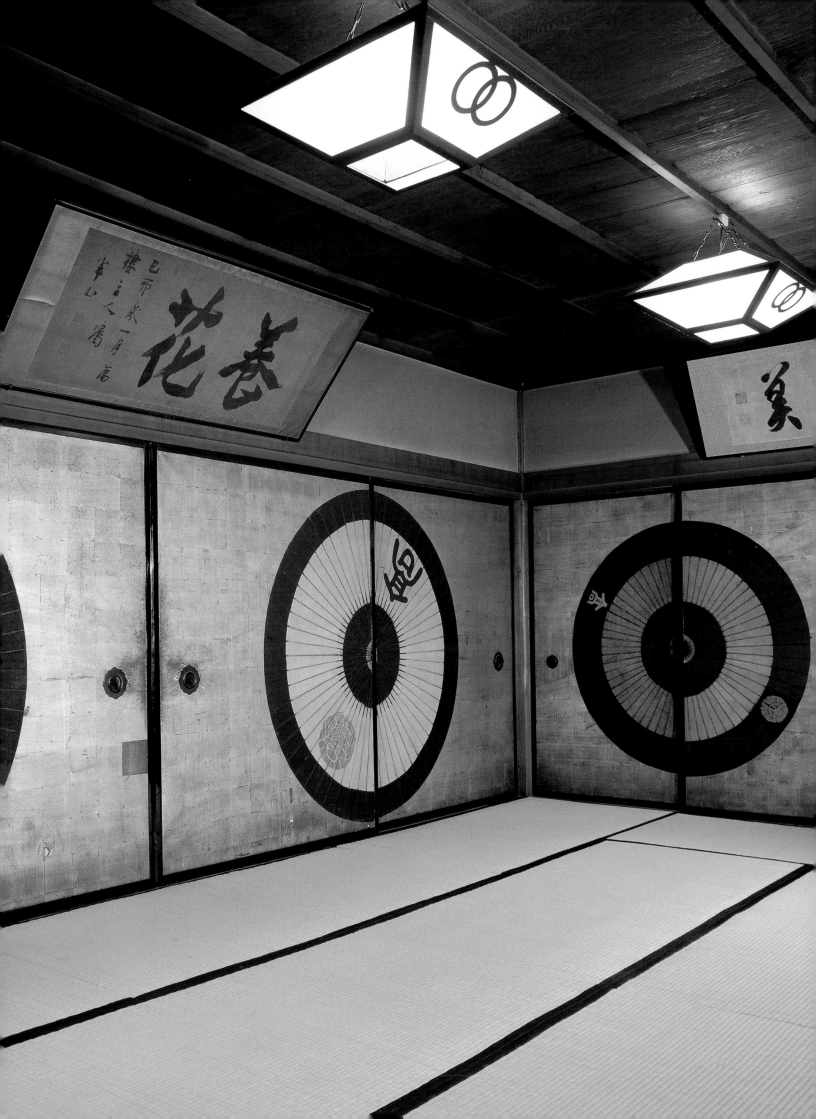

Sumiya, a designated Important Cultural Property, dates all the way back to 1641, and has been operated continuously by thirteen generations of the same family. It was expanded to its present size in 1787. Each room is decorated differently, with great originality and lavish attention to detail—sliding doors and folding screens are painted by luminaries like Yosa Buson (1716–83). The architectural style typified the rising class of urban merchants and artisans, combining the elegance and spaciousness of samurai mansions with the subtle refinement and naturalness of tea-ceremony rooms.

It is worth remembering that the *ageya* was not only the site of big parties, but it also functioned as a kind of cultural and political salon; haiku gatherings by renowned masters were held here, and in the waning days of the Edo period, political reformers met here to plot their moves. The historical and cultural significance of Sumiya is great.

In recent years, the *machiya* townhouses of Kyoto have begun to benefit from a vigorous grassroots movement to restore and preserve them not as museums, but as a living architectural heritage. It is gratifying that Wachigaiya and Sumiya are also being maintained as living reminders of a unique era.

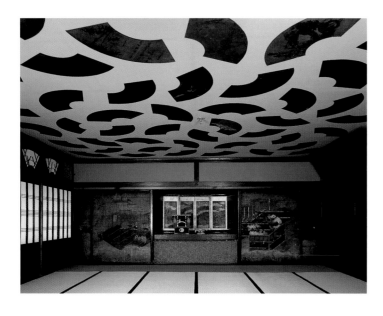

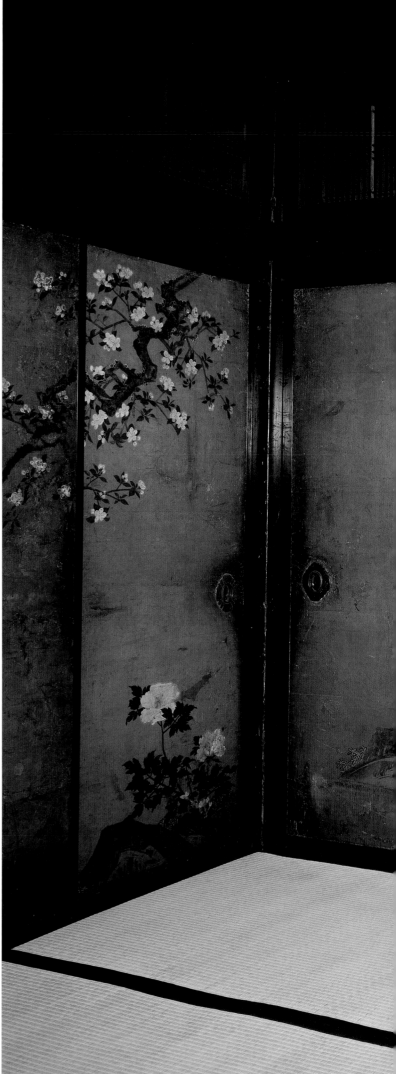

ABOVE: The Fan Room of Sumiya.
RIGHT: The Peacock Room of Sumiya.

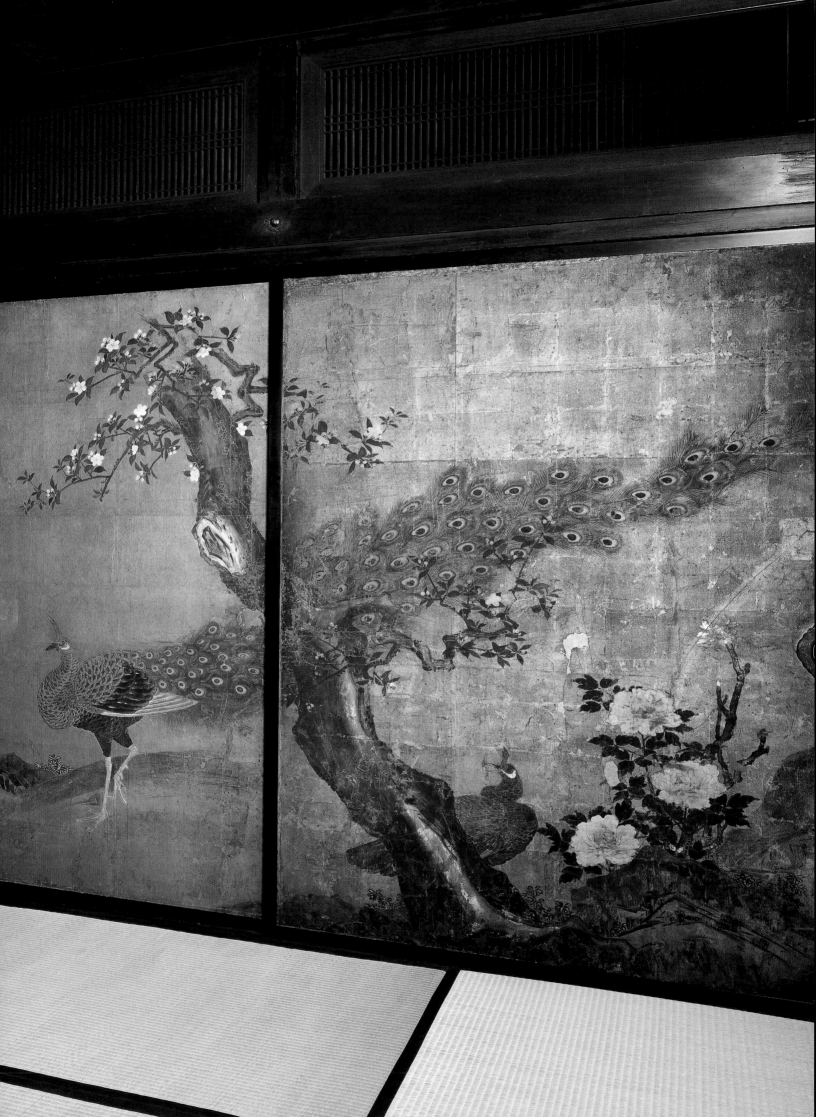

CUISINE

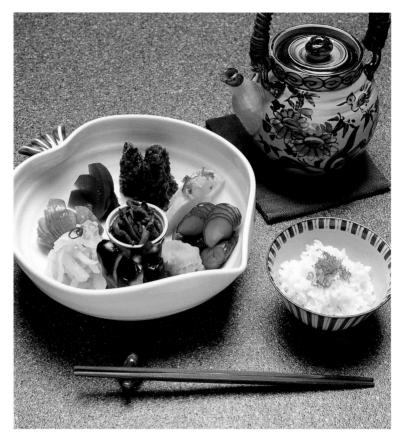

Kyo-ryori (Kyoto-style cooking) is the name given to a distinctive type of cooking that has arisen out of the local geography and customs. It is characterized by subtle flavoring and seasonal ingredients that convey a strong sense of the passing of the seasons.

Since Kyoto is inland, a long way from the sea, and Japanese traditionally did not eat meat, vegetables have always formed a central part of the local diet. There are approximately thirty varieties of special vegetables cultivated around Kyoto today, colorfully displayed in the central Nishiki Market. Perhaps the most famous of the many types of *Kyo-ryori* available are the vegetarian dishes known as *shojin ryori*, designed to serve the needs of Zen Buddhist priests and pilgrims. Typical dishes include *yudofu* (boiled tofu), cooked in a hotpot at your table with regional vegetables; steamed custard (*chawan-mushi*) made with yam instead of egg; skewers of toasted tofu topped with miso (*dengaku-dofu*); and a sesame-flavored treat with the consistency of tofu (*goma-dofu*).

Kyoto is also renowned for its *kaiseki ryori*, an elaborate meal that is carefully prepared and exquisitely arranged. Originally a light repast to be served before the tea ceremony, *kaiseki ryori* evolved into an elaborate, multicourse meal that blends many traditions: ceremonial court cuisine, Zen vegetarian cuisine, simple tea-ceremony dishes, and the local produce. The modern version generally includes meat and seafood. Again, there is strong emphasis on the season: fresh foods are cooked with light flavoring to bring out their natural flavors, the arranged dish often garnished with leaves, miniature flowers, or other items from nature that evoke a seasonal or poetic image.

Yet another style of Kyoto cooking is *obanzai*, traditional home-style cooking with many unique recipes going back generations. One dish called *imobo* consists of a local variety of potato (*ebi-imo*) boiled together with dried cod. Another important ingredient in many local dishes is *hamo* (sea eel or pike conger), which retains its vitality out of water for a long time. Pounded *hamo* mixed with burdock is a typical dish.

TOP: Kyoto-style pickles made from local vegetables at Kintame, a combination shop and restaurant. BOTTOM: A colorful assortment of *namafu* (delicacies made from wheat gluten) at Fuka. RIGHT: Kyoto-style New Year's cuisine at the restaurant Tankuma Kitamise.

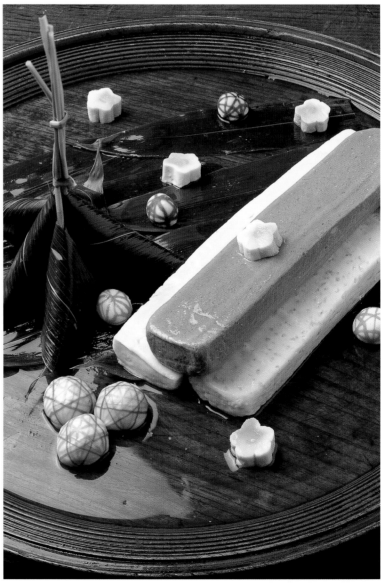

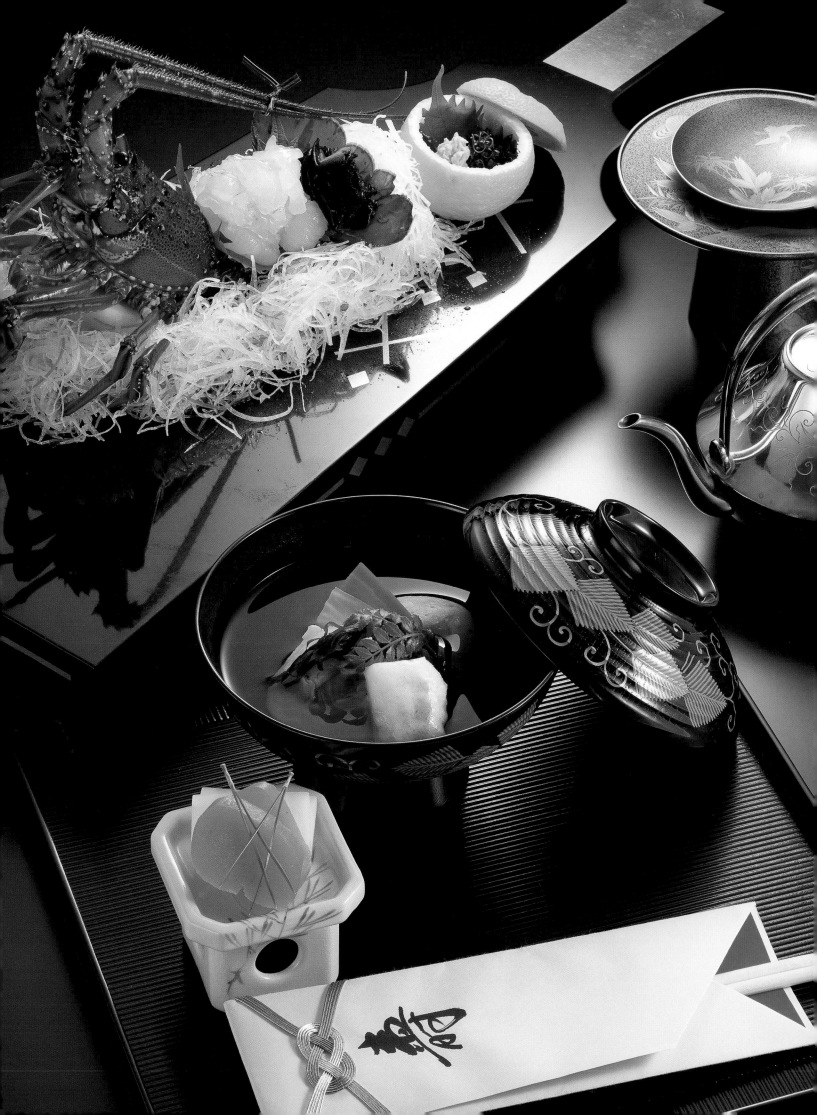

Kyoto offers a wide assortment of exquisitely shaped and delicious confections known collectively as *Kyo-gashi*. Some of the oldest family-operated confectioneries in Kyoto have been purveying sweets to the imperial family for hundreds of years. Confections originally developed for use at court or in religious ceremonies were further refined as they became incorporated into the tea ceremony, providing a sweet complement to the astringent flavor of powdered green tea. Today, *Kyo-gashi* are considered the finest of all native confections.

The design of many *Kyo-gashi* is based on natural forms and seasonal motifs, for it is expected that the confections will not only taste good but also convey a visual sense of the season. Sometimes actual leaves are used, as in *tsubaki-mochi*, a cake of pounded rice pressed between camellia leaves. Sponge cake in the shape of *ayu* (sweetfish) stuffed with sweet green bean-jam is another seasonal treat. For a confection called *higashi* ("dry candy"), carved cherry-wood molds are used to form treats in the stylized likeness of flowers, birds, or other designs. A maker of *kinton*, a tiny sweet potato-and-bean confection popular in summer, may summon all his artistic skill and sensibility to suggest a Kyoto scene through his craft.

Sometimes the seasonal association is conjured up with the confection's name: dried sweetmeats made by pressing rice flour, sweet *mizuame* syrup, sugar, and other ingredients into a mold are called *rakugan* ("alighting geese"), the black sesame seeds sprinkled over them suggestive of wild geese on a field of snow. A type of baked cake often served in the tea ceremony—made of wheat flour, miso, sugar, and other ingredients—is called *matsukaze*, or "wind in the pines."

The recipe for most Japanese-style confectionery is quite simple, consisting generally of sweetened red adzuki bean paste wrapped in a soft paste made from *mochi* (pounded glutinous rice), arrowroot, or the like. One of the most beloved of Kyoto confections is *yatsuhashi*, made of bean paste filling that is tinged with cinnamon and wrapped in a thin dough (*nama yatsuhashi*), often served in the shape of a folded triangle, or baked in the shape of a bridge or zither. The origin of the name is in dispute; some trace it to a famous musician of old, others to a bridge where a grieving mother mourned her lost child.

Scenes from a Kyoto sweets shop. **ABOVE:** The traditional entrance of Tawaraya Yoshitomi. **RIGHT:** *Kinton* confections made from bean paste and a design sketchbook, also from Tawaraya Yoshitomi.

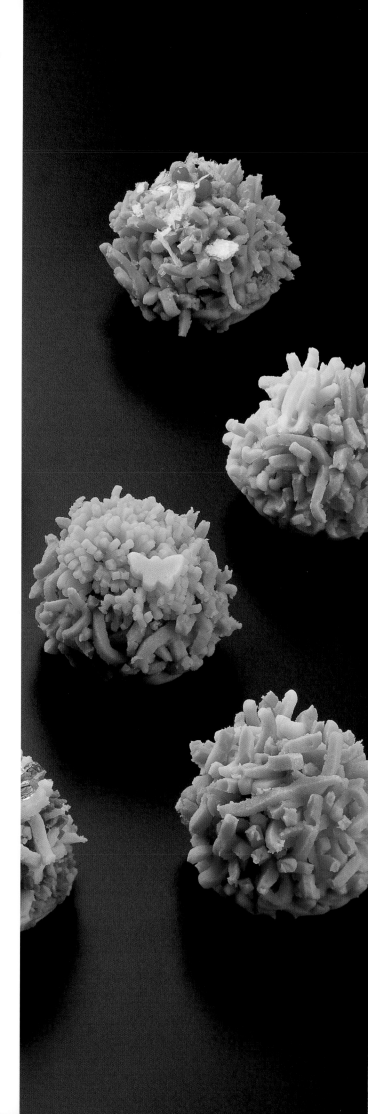

玉子
外團子
内常一

白餅
外内
常ン
ア

未開紅
上内外
白餅
引

紅毛た

蜜まんぢう

早梅

早梅
二行し

元下梅
二行し

A traditional *ryokan* such as the Tawaraya, Kyoto's oldest inn (run by the eleventh generation of the same family), offers the utmost in hospitality. Your visit begins with a warm, kneeling welcome by the *okami-san*, or mistress of the inn, at the entryway. You are then ushered down a hallway of polished wood—often a twisting, mazelike affair with views of indoor gardens along the way—to your private chamber, a typical Japanese-style room with a low lacquered table in the center, comfortable cushions to sit on, and a brocade armrest. Design is spare and low key. In the decorative alcove, or *tokonoma*, you will find a flower arrangement and a hanging scroll that reflects the season, and perhaps a priceless antique. Paper lanterns provide soft, muted lighting. Rooms in the Hiiragiya, another venerable inn, feature painted gold-leaf screens or ink paintings in the Zen style.

Soon after you have been shown to your room, a maid will appear with green tea, accompanied by a small sweet of some kind. As you enjoy it, you can take in the private garden view right outside your room—an oasis of tranquility. Or you may slip outside and stroll through the grounds. One of the newer luxury *ryokan* in Kyoto, the Awata-Sanso (originally built in 1937 as a private villa in the Higashiyama Hills), is set in a magnificent traditional garden with stone lanterns nearly a thousand years old.

After (or sometimes before) a soothing hot bath, either private or communal, dinner is served in your room. The meal will be a feast for the eye as well as the palate, artistically presented with full attention to contrasting colors, textures, and shapes, often on traditional ceramic dishes and lacquerware.

After dinner the maid will whisk away the dishes, remove the table and cushions, and lay out the *futon* directly on the straw matting. These consist of thick, comfortable mattresses covered with big, soft quilts. *Yukata* kimono double as sleepwear and loungewear.

Some Kyoto *ryokan* constitute important historic sites in themselves. Teradaya, a waterside inn dating back to 1597, played a role in the tumultuous days leading up to the Meiji Restoration of 1868. In 1862, nine people died there in the infamous Teradaya Incident; four years later, Sakamoto Ryoma (1835–67), a key figure in the Meiji Restoration, was set upon by more than twenty would-be assassins but managed to escape with the aid of the proprietor's daughter, whom he later married. His room is still available at an affordable price; upstairs is a wooden pillar nicked by a bullet from his pistol.

As an international sightseeing city, Kyoto naturally abounds in Western-style hotels and economical inns, not to mention Zen monasteries offering both accommodation (called *shukubo*) and a taste of a monk's life. But a luxury *ryokan* is one of the gems of Kyoto, a chance to experience impeccable service in surroundings of perfect serenity. In the words of novelist Kawabata Yasunari, speaking of his favorite Kyoto *ryokan*, "Here time stands still. It is here . . . that I wistfully recall that sense of tranquility that belonged to old Japan."

TOP: A courtyard garden at the inn Tawaraya. **BOTTOM:** A reading room at the same inn. **RIGHT:** A guestroom at Hiiragiya.

KYOTO CRAFTS

The crafts of Kyoto are part of its mystique. Home to the headquarters of major schools of tea ceremony, calligraphy, and flower arrangement, as well as the major sects of Buddhism, schools of No theater, and other performing arts, Kyoto has always attracted the finest craftsmen. Back lanes around the city are crowded with unpretentious establishments where a kaleidoscope of traditional crafts is still practiced, often by master craftsmen with unbroken direct lineage going back ten or fifteen generations. For centuries, the adjective "Kyo" before any product has been an assurance of the city's finest work. Kyoto is famous for its handcrafted dolls, fans (both folding and round), Yuzen dyeing, handmade paper, and brushes. Glass art, metalwork, woodcraft, and cloisonné are also associated with the old capital, along with dozens of other crafts from stone carving to Kiyomizu pottery to silk embroidery. Candlemakers work cheek by jowl with lacquerers. Paper umbrella makers are adjacent to shops selling handcrafted wooden tools, or painted fans. Down the road is a maker of bamboo baskets, or a specialist in bows used in traditional archery. Kyoto craftsmen often attract a succession of live-in apprentices from around the country, or indeed from around the world.

The traditional crafts of Kyoto are a precious heritage. At the same time, craftsmanship is also being redefined for the modern age, as artisans seek new shapes and uses for traditional objects. The spirit of creativity and uncompromising love of beauty and quality seen in Kyoto crafts remains a proud and vibrant tradition.

BELOW: A striking design of Kyoto embroidery. **TOP RIGHT:** A *Kyo-yaki* teabowl. **BOTTOM RIGHT:** A Kyoto-style painted fan. **FAR RIGHT:** Detail of a kimono *obi* sash of Nishijin brocade.

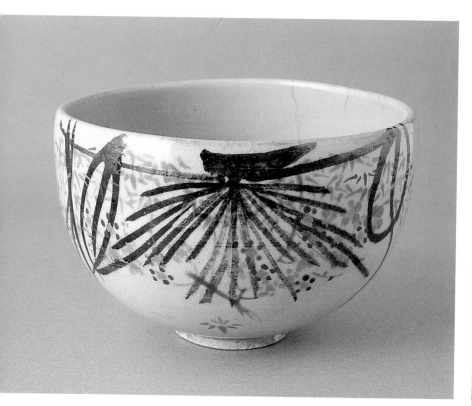

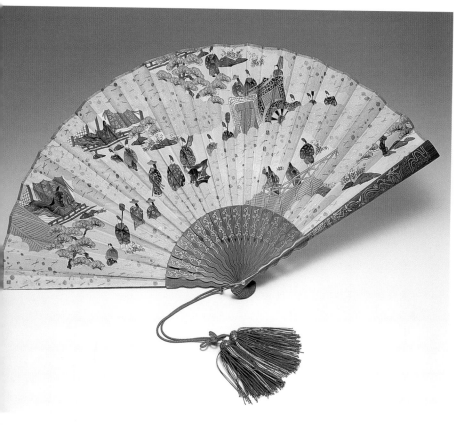

FESTIVALS

A host of festivals takes place in Kyoto throughout the year. The Holly-hock Festival (*Aoi Matsuri*), held annually on May 15, is one of the three grandest, and one of the oldest. It consists of a procession of five hundred people dressed in costumes of the Heian aristocracy, parading from the Imperial Palace to Shimogamo and Kamigamo shrines. The festival name is taken from the hollyhock leaves that adorn participants' headgear, the oxcarts they ride in, and the houses they pass along the way.

The Gion Festival, the second of the three main Kyoto festivals, dates back to an epidemic in 869 that laid waste to the capital. To placate the angry deity thought responsible, sixty-six tall spears, or *hoko*, were erected to represent the sixty-six provinces, and prayers were offered. Though interrupted by civil wars, the festival was revived and adapted by sixteenth-century merchants, taking on its present form during the Edo period.

Sponsored by Yasaka Shrine, the Gion Festival lasts the entire month of July. The highlight is on the seventeenth, when towering wheeled floats also called *hoko* are hauled through the streets in a parade attracting thousands of spectators. Standing eighty-two feet tall (twenty-five meters) and weighing twelve tons, the nine *hoko* are decorated with gorgeous tapestries, including some from medieval Belgium, Persia, and Turkey brought to Japan centuries ago. Each *hoko* is topped by a tall spearlike pole and carries a band of traditional musicians playing gongs, drums, and flute. Smaller floats called *yama*, twenty-three in all, stand six feet tall (1.8 meters) and weigh one and a half tons, though some *yama* are larger. At the Shijo-Kawaramachi intersection, the floats perform a ninety-degree turn with bamboo slats placed under the wheels, and people on top toss lucky charms to the clamoring crowds.

The other major Kyoto festival is the Festival of the Ages (*Jidai Matsuri*), begun in 1895 to celebrate the eleven-hundredth anniversary of the founding of the city. Its main event is a costume parade of two thousand people dressed as an array of court figures and heroes, proceeding from the Meiji period back to the Heian. The Imperial army from the time of the Meiji Restoration is shown, along with various court ladies, samurai, and rulers like Toyotomi Hideyoshi, shown going with his retinue to pay his respects to the emperor. The procession starts from the old Imperial Palace grounds, circles the downtown area, and ends at Heian Shrine.

RIGHT: Lanterns glow on the *Kitakannon-yama* float in the Gion Festival. **FAR RIGHT:** Detail of a seventeenth-century folding screen showing a float touring downtown Kyoto in the Gion Festival.

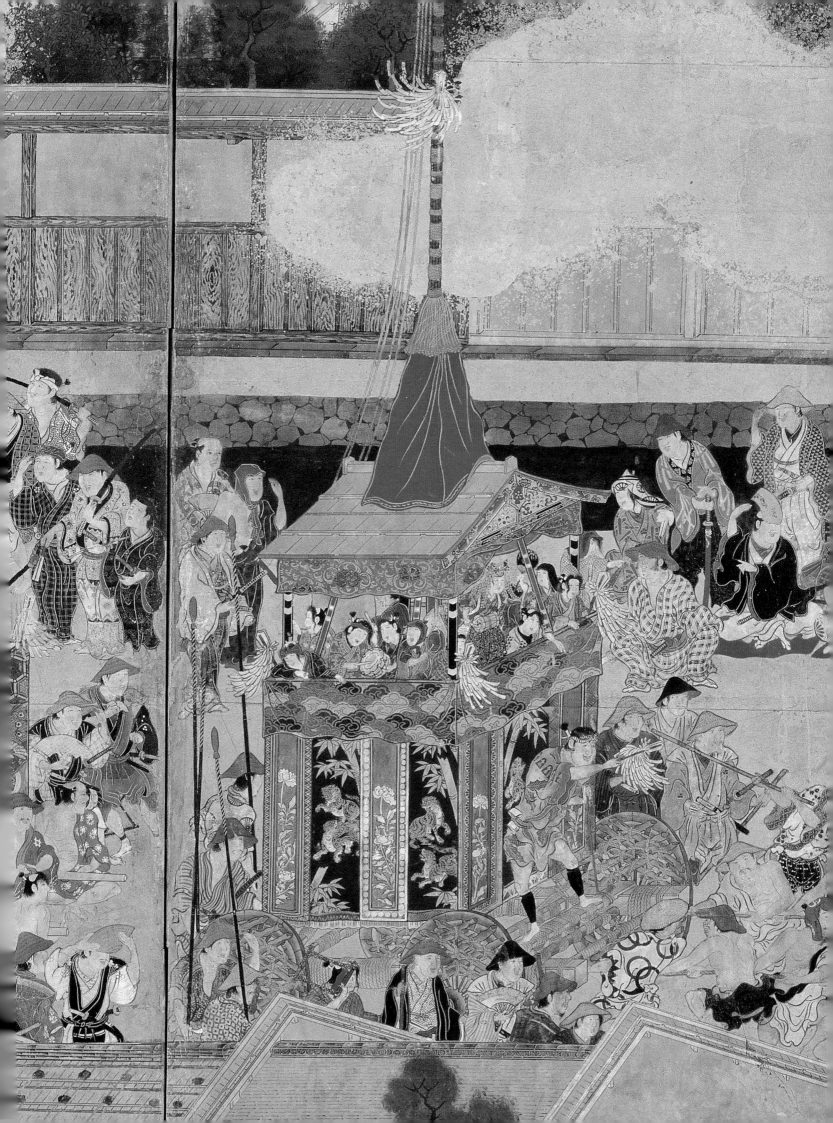

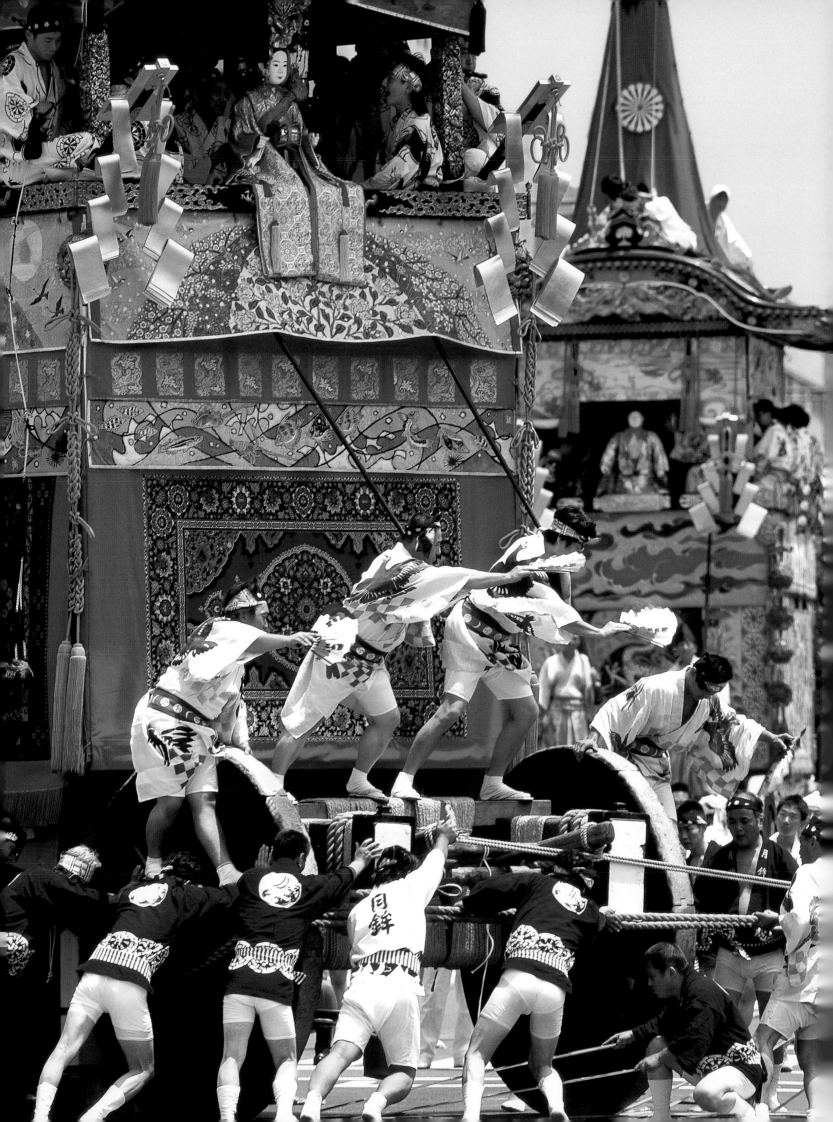

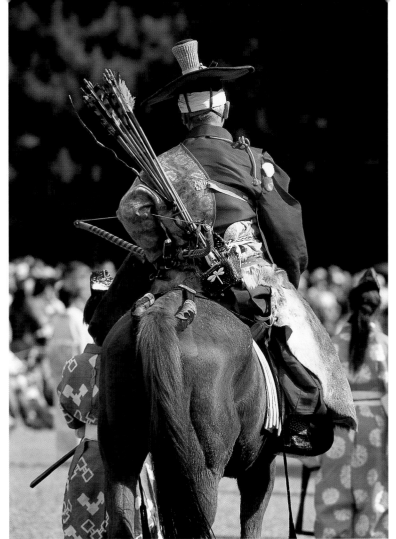

Held at nightfall on the same day is the spectacular Fire Festival of the temple Kurama-dera, on a hill in the northern part of Kyoto. Portable shrines are hoisted among crowds of villagers carrying small torches; later, young men wearing loincloths carry huge, sixteen-foot-high (five-meter) pine torches known as *taimatsu* through the village. The festival continues until dawn in the grounds of Yuki Shrine, a brilliant spectacle against the night sky.

Another fire festival marks the end of the midsummer Bon Festival. On August 16, a bonfire is lit in the shape of the Chinese character *dai* ("great") on Mt. Nyoigatake, followed by smaller fires in different shapes on four other mountains around Kyoto. In this way, people see off the souls of ancestors returning to the afterworld.

FAR LEFT: Turning the corner is achieved by pulling the massive float sideways over wet bamboo slats. **LEFT:** A Festival of the Ages participant dressed as a horseback archer. **BELOW:** An ox-drawn cart decorated with wisteria as part of the Aoi Festival.

OVERLEAF: A bonfire in the shape of the character *dai* (great), a part of the Fire Festival.

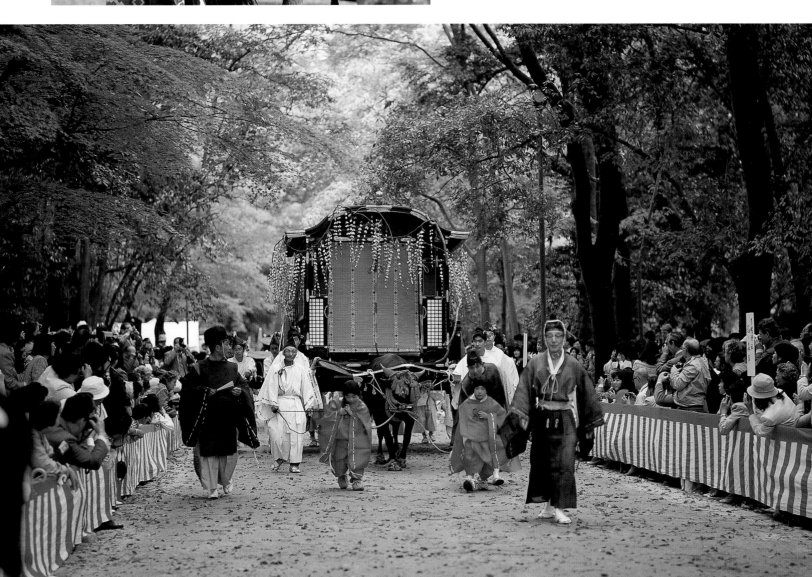

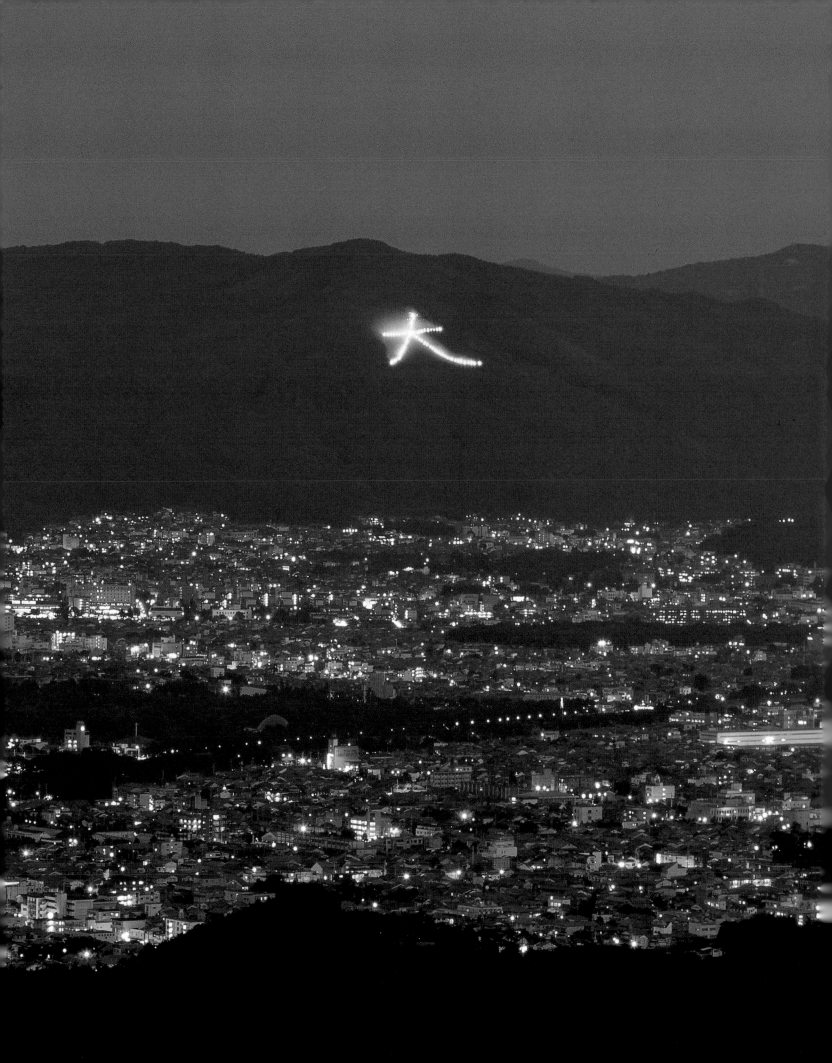

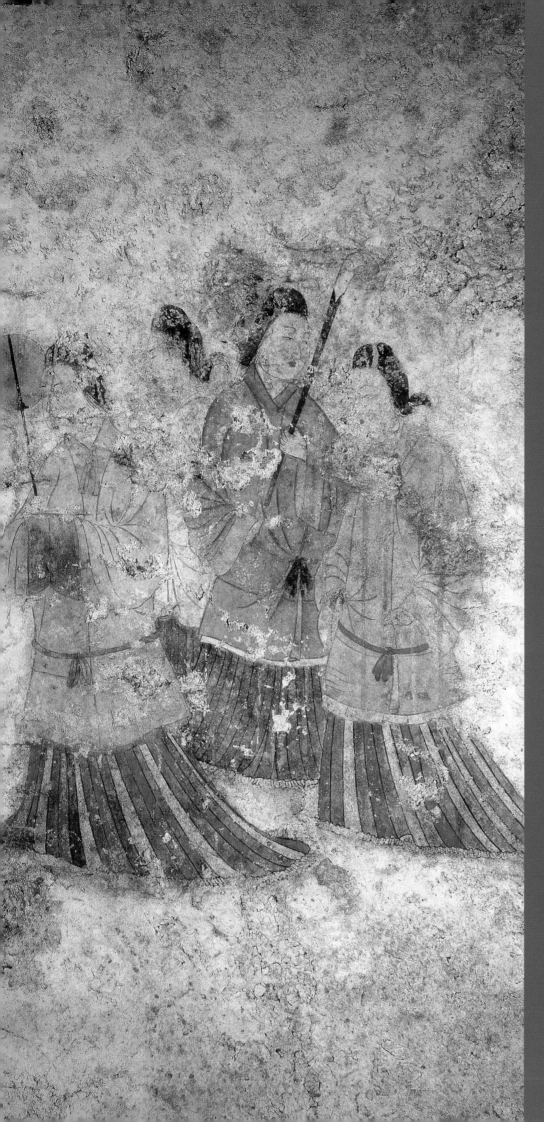

PART III

NARA IN HISTORY

Nara is in a sense the very essence of Japan. The city has played a crucial role in the nation's tumultuous political, religious, and cultural history. It is overflowing with archaeological, architectural, and artistic treasures, not to mention natural beauty that poets have sung through the ages.

Now, as the city looks forward to the thirteenth centennial of its birth in 2010, is a fitting time to reflect back on the place of Nara in Japanese history. First we will set the stage by looking briefly at the Asuka period, when Buddhism took root in Japan, and then consider the Nara period, when the city was in its glory.

LEFT: Painting of a group of women from the ancient Takamatsuzuka burial mound in Asuka.

THE ASUKA PERIOD
(593–710)

Among the first accolades to Nara are these words attributed to the legendary Jinmu, Japan's first recorded emperor, in B.C. 667: "Oh, what a beautiful country we have become possessed of!" He was speaking of the Yamato Plain, a small, fertile area surrounded by mountains; here, or in this vicinity, his descendants would rule for nearly two millennia.

The coronation of one of those descendants, the empress Suiko (554–628), took place in 593 in Asuka, on the southeastern edge of the Yamato Plain and eighteen miles (thirty kilometers) south of Nara. Her reign was marked by numerous embassies from Paekche on the Korean Peninsula; members included scholars, priests, sculptors, and builders. Asuka-dera, modeled on the layout and architecture of temples in Paekche, was the first Buddhist temple compound ever constructed in Japan. By quickly declaring her acceptance of Buddhism and encouraging the building of other monasteries, Empress Suiko made sure it was not the last. Her nephew Prince Shotoku (574–622), Buddhism's staunchest advocate, ordered the construction of several more, one of which grew into the great seminary of Horyu-ji. At the time of his death, there were dozens of monasteries around the country with hundreds of monks and nuns. Japanese Buddhism was in full flower.

Horyu-ji today boasts the world's oldest wooden buildings. It also houses a magnificent collection of Buddhist sculpture and art showing strong continental influence. Tamamushi (Jeweled Beetle) Shrine, the personal altar of Empress Suiko, is inlaid with Buddhist murals formed by the wings of thousands of iridescent beetles.

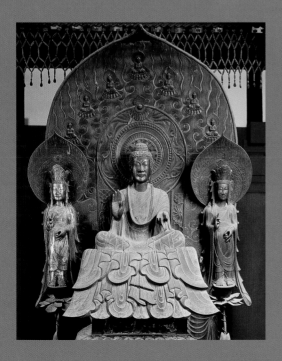

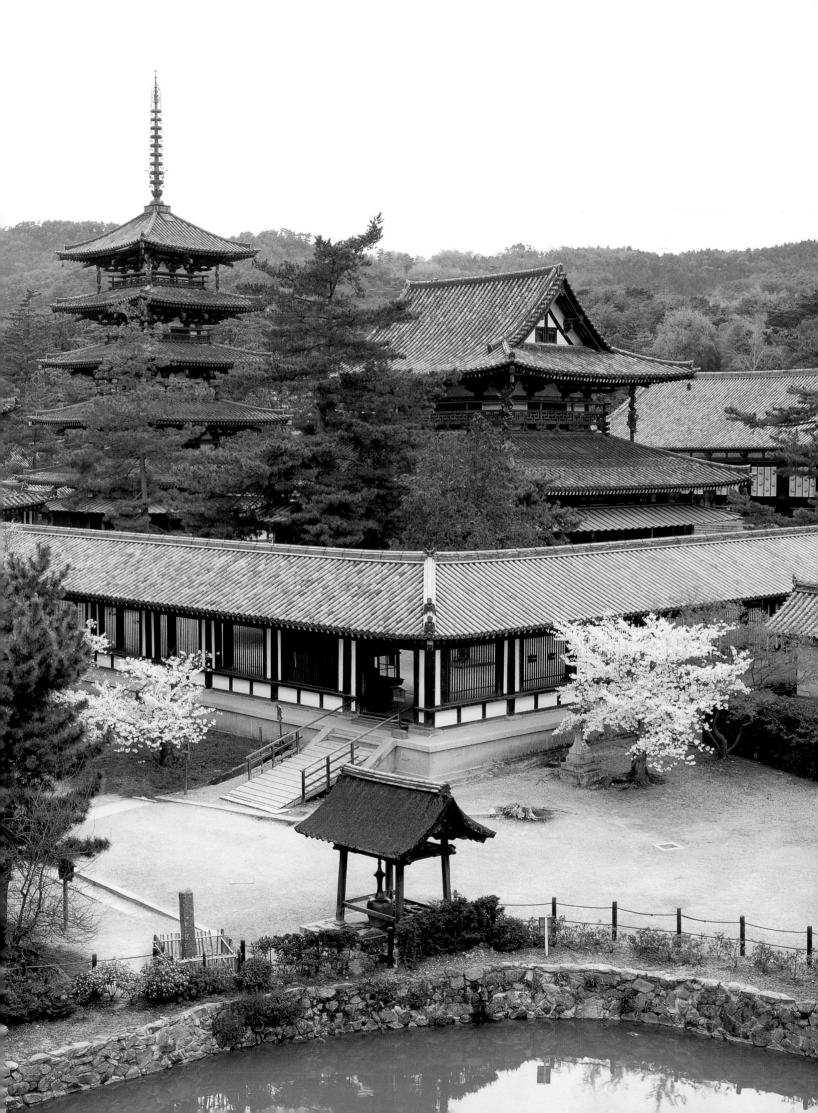

THE NARA PERIOD

(710–94)

Heijokyo, the ancient name for Nara, was chosen as the new "permanent" capital in 710. Fujiwara no Fuhito (659–720), a patriarch of the powerful Fujiwara clan, helped engineer the move to the new capital and established Kofuku-ji and Kasuga Taisha, the family temple and shrine, as its official protectors. (Of the 175 buildings that once stood in the temple grounds, only four main structures survive, including the striking five-storied pagoda.)

The founding of Heijokyo, splendid with green tile roofs and vermilion columns, was a watershed for the Japanese. Though the Nara period was to last only some seventy years, it saw the nation unified under a central authority. Where previously the Japanese had looked to Korea for inspiration, now relations with China flourished; the new

BELOW: An aerial view of the temple Kofuku-ji with Mt. Kasuga in the background. **RIGHT:** A lacquer sculpture of Ashura at Kofuku-ji.

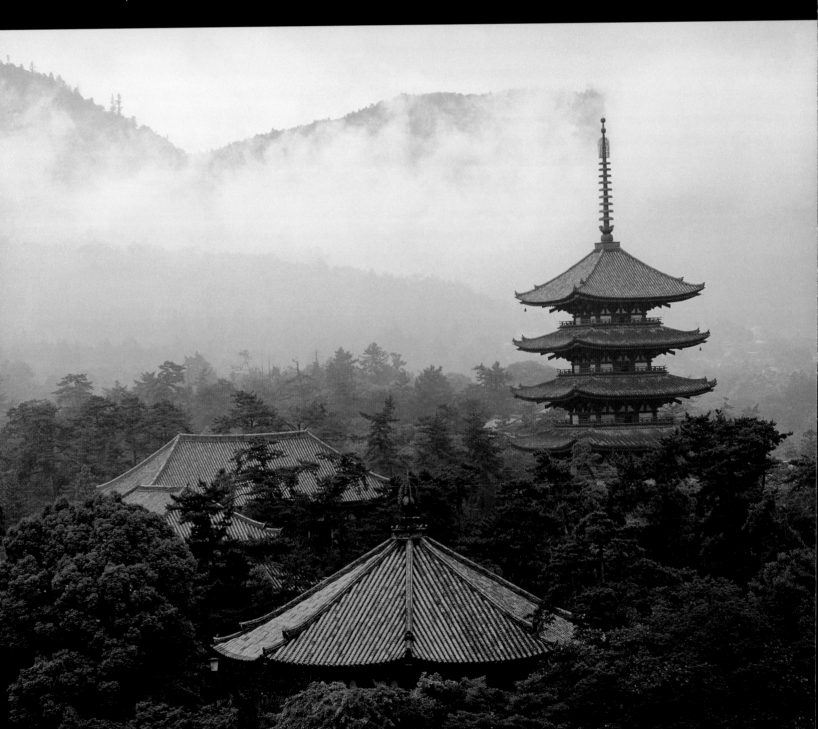

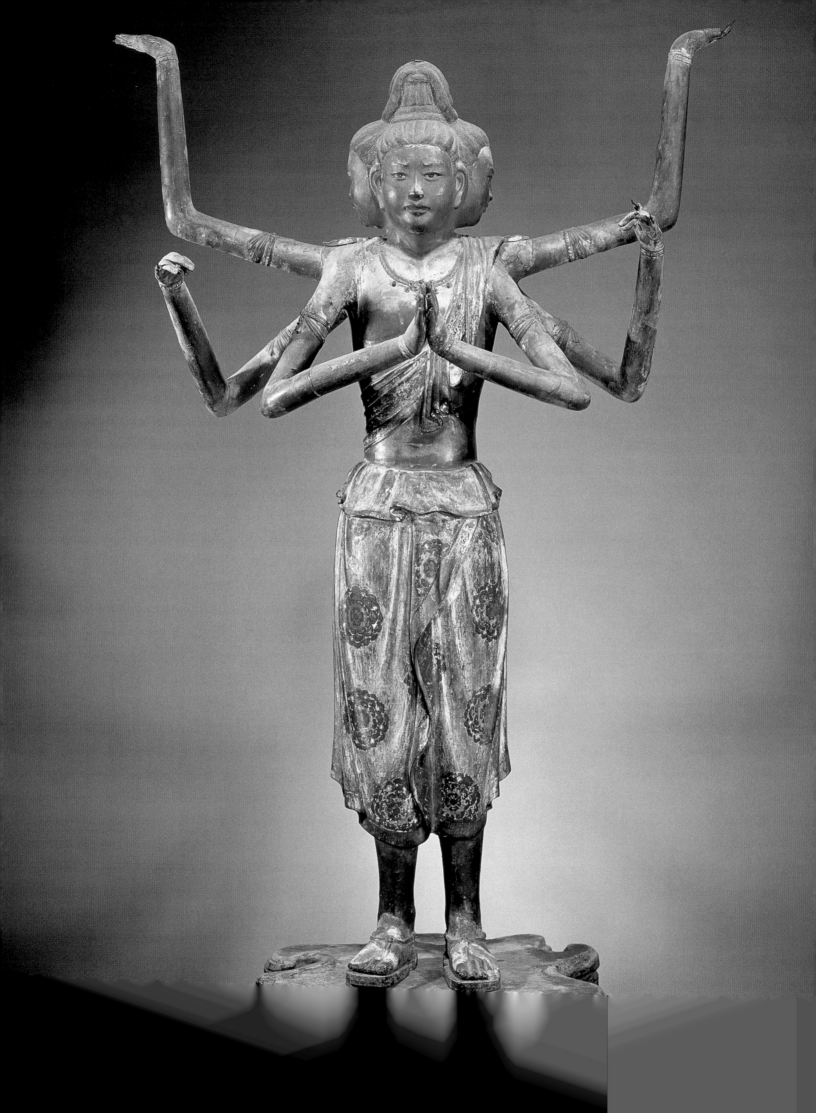

capital adopted the symmetrical grid plan of Chang-an, the Tang capital. Heijokyo was a cosmopolitan place with visitors from as far away as Indonesia, Vietnam, India, and Central and West Asia. Amid this cultural diversity, huge achievements in the arts, literature, and architecture established Japan as one of the great nations of the world.

■ ■ ■

The imperial city of fairest Nara
Glows now at the height of beauty,
Like brilliant flowers in bloom.

These lines are from the *Man'yoshu* (Collection of Ten Thousand Leaves), a compilation of more than four thousand poems by people of all social ranks; from the mid-eighth century, it remains one of the most beloved treasures of national literature. Two vast histories of the nation, the *Kojiki* (Record of Ancient Matters, 712) and *Nihon Shoki* (Chronicle of Japan, 720), were completed shortly after the move, crowning the young capital and its ruler with further distinction.

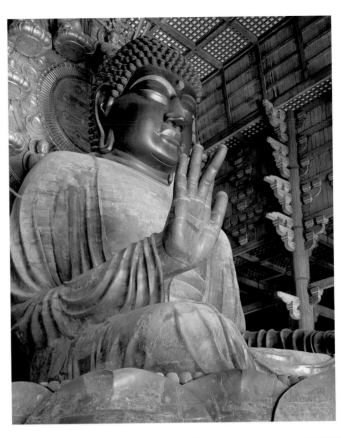

RIGHT: The Great Buddha at the temple Todai-ji. **FAR RIGHT:** Monks gather at the foot of the Great Buddha for a ritual observance. **BELOW:** The sacred ceremony of Omizutori, at Todai-ji.

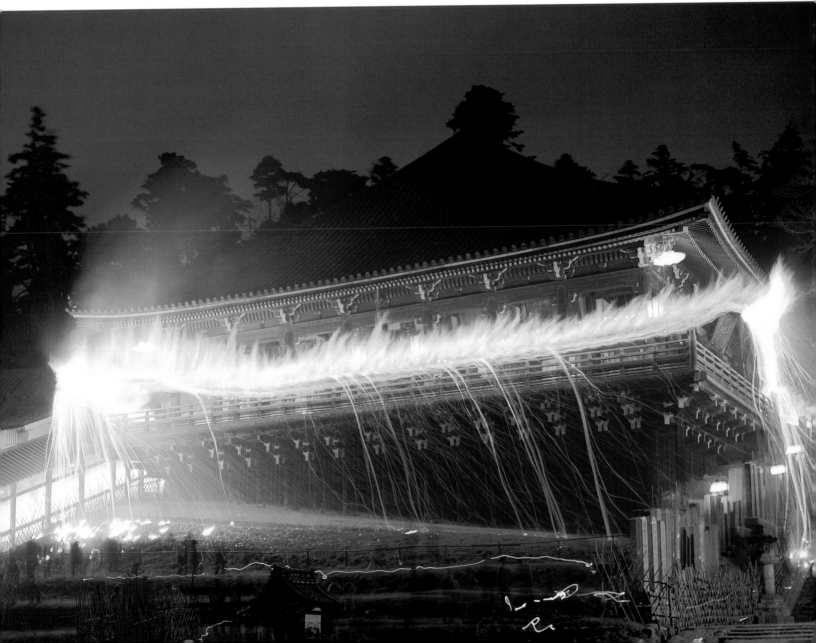

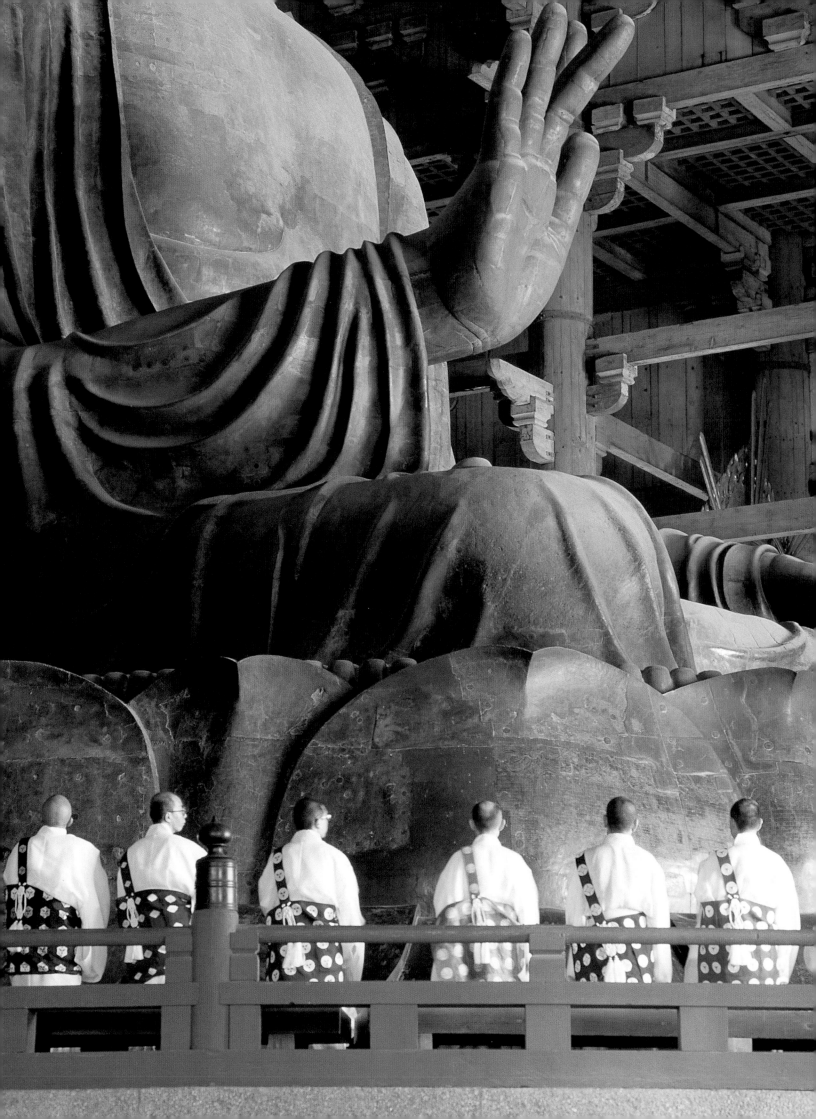

Another landmark achievement of the era was the completion of the colossal Great Buddha during the reign of Emperor Shomu (701–56). Fifty feet (fifteen meters) high, it is the largest bronze statue in the world and is housed in the largest wooden structure in the world, the Daibutsu-den, or Great Buddha Hall of the Todai-ji. Emperor Shomu ambitiously ordered the statue constructed as an overpowering symbol of imperial sovereignty in order "to bring about peace to the state and enlightenment to the people." Its making exhausted the nation's stores of gold and imposed a fearful burden on conscripted peasants. The statue was dedicated in 752, with the founding of the temple Todai-ji, and lasted unscathed until 855, when its head toppled off in an earthquake. Swiftly repaired each time it suffered damage, the statue remains an awe-inspiring sight to this day.

The Silk Road is said to have ended in Nara at the Shoso-in, a cypress-log repository that housed an array of treasures submitted to Todai-ji. Many precious objects were presented to Emperor Shomu by envoys from across Asia on the occasion of the dedication of the Great Buddha; others were donated by his widow, following his death. Highly skilled native artisans and immigrants from China and Korea made many of the treasures, which include paintings, musical instruments, masks, swords, *go* boards, mirrors, Persian cut glass, silver vessels, fragrant Indian wood, cloths, medicines, cosmetics, and more.

Toward the end of the Nara period, the Chinese monk Ganjin (689–763) arrived in Nara and founded the temple Toshodai-ji in an attempt to reform Japanese Buddhism, which had grown lax in the luxurious capital. Second only to Horyu-ji in antiquity, Toshodai-ji has many intact buildings and images of profound beauty. The realistic lacquer statue of the blind old monk is one of the most celebrated works in Japanese art.

Finally, as the influence of the seven great monasteries (one for each of the major sects, plus the Toshodai-ji) in Nara threatened to eclipse the authority of the Imperial House, the emperor Kanmu (737–806) decided to move the capital in a bid to restore the power and prestige of the throne. Overnight, the former capital became a symbol of the old, and the new capital—Heiankyo, or Kyoto—took on the mantle of the new.

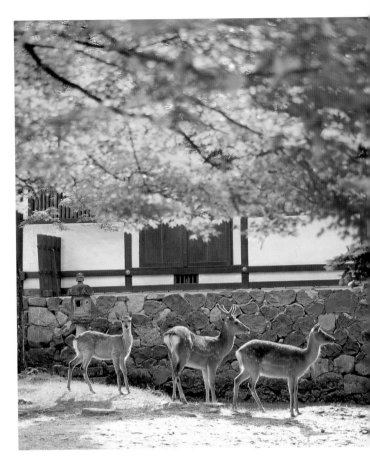

TOP: Deer in Nara Park. BOTTOM: Lanterns and wisteria in the shrine Kasuga Taisha.

PART IV
KYOTO AND NARA TODAY: BUILDING ON TRADITION

The cultural riches of Kyoto and Nara, Japan's two old capitals, have brought them worldwide fame. Nara retains a serene beauty and warmth, while Kyoto, in keeping with its status as the home of successive emperors across the centuries, proudly maintains an unparalleled tradition of courtly grace and superb craftsmanship. But the cities' claim to fame is not based exclusively on ancient customs, temples, palaces, and gardens. Especially in Kyoto, less well known but equally important is a strong tradition of innovation and enterprise. Let us examine first how Kyoto has constantly reinvented itself, before we go on to consider some of the issues and challenges facing both cities today.

Back in the early Heian period (794–1185), after absorbing Chinese influence, Heiankyo (today's Kyoto) became the focal point of a vibrant new economy, attracting entrepreneurs and artisans from around the country. The city flourished as the center of government, commerce, and culture. Over the centuries, though ravaged repeatedly by wars, fires, plagues, and disasters, it always reemerged triumphant, buoyed by its special status as the cultural soul of Japan. Then with the Meiji Restoration of 1868, as Japan entered its modern era, the capital was shifted east to Tokyo. Worse, the young emperor also left Kyoto. From then on the city would be known, like Nara, as a *koto*, or old capital. But Kyotoites refused to sit on the sidelines. In the face of this devastating blow, they moved quickly to score a number of important firsts, displaying admirable inventiveness and resilience.

The first action taken by residents in the spring of 1869 indicates not just their enterprising spirit but their deep respect for education: they banded together to found the first modern elementary school in Japan. Pooling their private resources, citizens in various districts opened sixty-four such schools in all—fully three years before the national government established the framework for a modern public educational system with the Educational Order (*Gakusei*) of 1872. A short time later, in 1880, Japan's first school of fine arts (presently the Kyoto College of Fine Arts) was established inside the Kyoto Imperial Garden.

Commitment to education is unabated in Kyoto today. With forty-seven public and private colleges and universities, the city boasts more students per capita than anywhere else in Japan. Among private institutions, Doshisha and Ritsumeikan universities are well known, while the national Kyoto University ranks with Tokyo University as a leader par excellence of Japan's academic community; its faculty of sciences has produced no less than half of Japan's Nobel Prize laureates, as well as other luminaries. The university is also renowned for its information science faculty. In 2000, Kyoto University and the University of California at Los Angeles (UCLA) jointly taught two courses in which students in each classroom could see and hear one another and the professor in real time; this marked the first time live lectures and synchronized interactive multimedia were offered between universities over the Internet.

Another major advance in Kyoto academia took place in 1998, when the Kyoto Consortium of Universities was incorporated as a public foundation, with over forty institutions of higher learning involved. Meanwhile, on a green, hilly area extending over Kyoto, Nara, and Osaka prefectures, the Kansai Science City has been set up as a national project for the advancement of culture, scholarship, and research. The mix of these intellectual resources with Kyoto's long history and tradition provides an ideal milieu for innovation and creativity.

Transportation and civil engineering are other areas where Kyoto has shown great innovation. A canal built in 1890 to connect the city with Lake Biwa and supply it with hydroelectric power attracted worldwide attention in its day. Now, more than a century later, the twelve-mile (twenty-kilometer) Sosui Canal and its power station continue to work just as before. As early as the 1920s, the development of other means of transporting goods changed the canal's primary role of water transportation to one of supplying the city with drinking water, which it still fulfills.

Today, by the Eastern Hills of the city, one can enjoy a tranquil stroll along a shaded branch of the canal known as Philosopher's Path, named for the eminent philosopher Nishida Kitaro (1870–1945), a professor at nearby Kyoto University who, for many years, made it his practice to walk there every morning. The path links the classic temples Nanzen-ji and Ginkaku-ji, meandering past shrines, trendy boutiques and cafés, and attractive private homes. The charm of the old canal with its many stone bridges is enhanced by hundreds of cherry trees, beautiful year round but never more so than in spring, when ablaze with blossoms.

Thanks to the power plant, Kyoto became the first city in Japan to have trams powered by electricity. In 1895, Kyoto introduced the nation's first streetcars, nicknamed *chin-chin densha*, or "ding-ding trains," because of the sound of the bell rung by motormen as a starting signal. Implementing a streetcar system led to the widening of city roads and other improvements, but in 1978 the last of the streetcars was phased out, and today a network of subways has taken over the old streetcar routes.

A twenty-minute subway ride heading north from Kyoto Station on the Karasuma Line will take you to the Kyoto International Conference Hall (KICH), an elaborate, state-of-the-art complex for meetings and exhibitions that lies nestled in greenery at the foot of Mt. Hiei, by Lake Takaragaike. The complex opened in 1966 as the first international conference center to be built in Japan. From the earliest stages of planning, Kyoto was designated the site for the hall so that conference attendees might enjoy surroundings of great natural beauty, with treasures of Japanese history and culture at their feet. The low, wide complex is fully digitalized, with many specialized facilities and services, including simultaneous interpretation available in six languages. It also has a teahouse and magnificent gardens where outdoor events for as many as four thousand guests can be held.

Since its inauguration, KICH has hosted numerous international conferences in fields of all kinds. Notable events include the Third World Water Forum of 2003 and the presentation ceremony for the 2004 Kyoto Prize, an award offered annually to "those who have contributed significantly to the scientific, cultural, and spiritual betterment of mankind." Most famously, the facility is the site of the Third Session of the Conference of the Parties (COP-3) United Nations Framework Convention on Climate Change that produced the Kyoto Protocol. Ever since that event in 1997, the name "Kyoto" has been synonymous around the world with rigorous efforts to control greenhouse gas emissions and forestall global warming. Thus, thanks to KICH, Kyoto has become widely associated in the public mind not only with tradition and legacies from the past, but also with cutting-edge research and thoughtful concern for the future.

In fact, many high-tech companies have chosen Kyoto as their headquarters; indeed, the ancient capital is considered one of the top up-and-coming cyber-sites in the world. A relatively free business climate has helped to nurture enterprise. Kyoto is the home of world-renowned manufacturers like Nintendo, Rohm, Murata, Wacoal, Omron, and Daihatsu. Kyoto Research Park, in the city center, has also attracted an international community of high-tech venture developers and academic researchers, both Japanese and foreign. More than 170 European and American companies have established headquarters there to help Kyoto develop its venture economy, while gaining assistance as they seek entry to the markets of Japan and elsewhere in Asia. Kyoto Research Park has made Kyoto a leading incubator of international business.

Perhaps the most spectacular example of Kyoto's confident commitment to the future is Kyoto Station, designed by local architect Hara Hiroshi to commemorate the twelve hundredth anniversary of the founding of the Heian capital. Completed in 1997, the ultramodern building is the latest reconfiguration of the station, which has stood at the southern edge of the main part of the city in one form or another since 1877. Despite an initial storm of controversy, the station has become the newest showcase for, and symbol of, the city. It stands as a modern reaffirmation of Kyoto's traditional identity as the center of Japanese culture and Japan's premier tourist destination.

A French writer once commented that "the railway station is so ingrained in the very network of our daily routines that one no longer notices it, one no longer sees it." Kyoto Station, however, is far from being either invisible or forgettable. The second-largest station building in Japan (only Nagoya boasts a larger station), it is approximately 65 yards high and 500 yards long (60 by 470 meters). The long, horizontal exterior is striking, featuring a rectangular façade of plate glass over a steel frame. Inside the monumental building is a complex of sixteen floors, three of them below ground, with (in addition to the usual station facilities) government offices, theaters, a 539-room hotel, a department store, an arcade, a *manga* shop and library, an underground shopping mall, and restaurants and cafés of every description, as well as extensive parking. In front of the station is a large conference and events building called Kyoto Campus Plaza, owned and run by the Kyoto Consortium of Universities, which further underscores the station's cultural significance.

Inside the Cube, as it is known, one encounters a vast internal space, fashioned with steel frame and glass roof, that opens to the sky. Long escalators carry visitors through terraced levels to an "open sky plaza" commanding a fine view of Kyoto. Across the way, on the opposite side of the concourse, is a huge stairway that can also be used for live performances. The east and west upper areas of the station are connected by an aerial corridor that provides great views of the station interior and of the open-air, nineteenth-century train tracks—a reminder of the original function of the area, lest one forget.

The sweeping scale of Kyoto Station is certainly imaginative and refreshing, especially given the often cramped reality of life in Japan; the soaring spaciousness is so striking that in some respects the building seems to resemble a modern, airy cathedral, and in others a futuristic space station.

But none of this has appeased those for whom the station represents nothing less than a betrayal. They scorn the station building as not grand but grandiose, not visionary but megalomaniacal in nature. Opponents have lambasted the Cube as a rejection of traditional Kyoto and a thumb to the nose at the past, an ungainly block structure in a city of graceful curves. Unflattering comparisons have been made with Rashomon, the Heian gateway to the city made famous by film director Kurosawa Akira.

The controversy has noticeably died down of late, however, as the sleek, steel-gray station wins a consistent thumbs-up from foreign and out-of-town visitors and becomes increasingly familiar to residents, who revel in the convenience and sophistication of its various transportation, shopping, and cultural facilities. (In this the station differs from Kyoto Tower, which was built across from the station in the mid-1960s and is universally reviled as ugly; its one redeeming feature appears to be that it is a useful tool for orienting oneself in the city.)

Although the outcry may have faded, the initial bitterness of the opposition to Kyoto Station suggests not just an aesthetic disagreement but a deeply felt underlying conflict—one that is faced in varying degrees by cities and towns all over Japan. There thus arises the question of how it might be possible to simultaneously preserve the past and modernize for convenience and development. How does an ancient city reconcile the demands of the past with those of the future? Which needs are paramount? These difficult questions must be faced by each successive generation.

In Kyoto, geography and topography are a key part of the problem. Unlike Osaka and Kobe, the two other largest cities in the Kansai region, Kyoto is landlocked and, therefore, cannot create space by reclaiming land from the sea, as those port cities have done—the latest example being Kansai International Airport, which opened in 1994 on a large rectangular manmade island in Osaka Bay. Also, the mountains encircling Kyoto, however beautiful, represent a physical barrier to expansion of the city limits. Under these circumstances, companies wishing to expand their business in the city, or to improve their efficiency and effectiveness, can only renovate old buildings—or, as happens more often, tear them down and build anew.

This situation has raised concern about the potential breakdown of Kyoto's traditional cityscape. Besides the vulnerability of traditional features like alleyways and townhouses, and the mishmash effect of mingling new structures with old, people's attention is focused on the skyline. For centuries, five-story pagodas were Kyoto's loftiest structures and no part of the city was cut off from views of rolling, wooded mountains. But over the years, traditional height limitations on buildings have been slowly relaxed, going up from 22 yards to 34, then 50, then 65 (20, 31, 45, and 60 meters, respectively), this last the height of Kyoto Station. The 17-story Kyoto Hotel, whose construction was protested to no avail by temple monks and lay residents alike, is held up as an example of how the view of the mountains from downtown is indeed being altered. Many people are on alert, determined to prevent developers from filling the city with a full complement of skyscrapers and thus obliterating its unique character.

Of course, not all new projects are controversial. Some additions to the landscape have been applauded for the way they blend into the natural environment beautifully and unobtrusively. Two examples are the Sumitomo Museum for Chinese bronzes and paintings, with its effective use of "borrowed" (*shakkei*) landscapes, and the Time's fashion complex along the Takase Canal, by renowned architect Ando Tadao. These and other projects suggest how a city may modernize without relinquishing beauty or character. To conserve the historical and cultural environment, meanwhile, the attention being paid to keeping Kyoto's *machiya* townhouses as part of a living tradition is encouraging. As the city moves ahead with plans to revitalize other areas, including the gritty area south of Kyoto Station, these lessons must be applied.

Nara, of course, has had to face the identical issue of preserving the past while stepping into the future. Sightseeing is a major industry in Nara, as it is in Kyoto; out-of-town visitors come expecting to see not a modern city but one that has remained old and traditional, while residents expect modernization and growth. Nara city fathers are encouraging modernization even as they weigh the demands placed on them by history. Utilizing the site of a former rail yard, the area around Nara Station is undergoing vigorous redevelopment; a civic hall, hotels, and commercial facilities are being constructed with the avowed aim of forming a new core of cultural and commercial activities. Across from the station is Centennial Hall, a major conference center where in 1999, just three months after the inscription of the Historic Monuments of Ancient Nara on the World Heritage List, Nara hosted a seminar that brought together city policymakers and urban planners from eleven Asian and European historic cities to discuss the preservation of urban cultural heritage and the development needs of modern society.

The rebuilding of JR Nara Station offers an interesting contrast with that of Kyoto Station, and illustrates another approach to the problem of balancing competing interests. The old station building, a charming example of early Showa-period (1926–89) architecture combining features of Western and Japanese architecture, was due for destruction, to be replaced with an elevated railway line scheduled for completion in

2010. When the plan became known, a grassroots movement sprang up to save the building. The station building was still solid enough to withstand earthquakes, citizens argued, and was a beloved landmark that it would be a crime to destroy. In the end, they won out. The station was hoisted up and rolled slightly to one side, where today it gazes benignly on the plain-looking (and no doubt highly functional) concrete structure that has replaced it.

Some fear that Nara will be ruined by just such a mixture of contemporary buildings and traditional architecture. To halt the process of replacement, Nara Machi, an area dominated by more than thirty temples and a row of old stores and houses, was labeled a preservation district in 1994. Residents now receive subsidies to help maintain the tiled roofs, wooden front entrances, and traditional latticework of their historic homes. While any changes to the exterior must meet with formal approval, the interiors may be modernized or used in any way desired; some of the shop-houses in this traditional merchants' quarter have been converted into museums or craft shops. Construction of any new houses, however, must be done so as to fit in with the general ambience, in accordance with precise guidelines. Similar plans have been put into effect in Kyoto; in this way, the old capitals are striving to accommodate citizens' needs and heed their voices while maintaining the integrity of their historical, cultural, and natural environment.

In 2010, Nara will celebrate the thirteen-hundredth anniversary of the transfer of the capital to Heijokyo. Plans are underway to make the past come alive through a multitude of exciting events such as open-air theatricals; a parade illustrating the pageant of history; a History Road down which visitors can wander to experience firsthand the march of history across the ages; a historical-film festival; an outdoor art festival; and a Silk Road festival, including the performing arts of various Asian cultures. Organizers hope to remind people of the exhilarating international mix out of which Japanese culture originally grew, and encourage a similar synergy today. Other exhibitions will reexamine landmark events like the construction and preservation of the Great Buddha, consider ties between Heijokyo and elsewhere, and link present and past on a more intimate level by focusing on the expression of love and wisdom in ancient times. The old Heijo Palace site will be further rebuilt and developed. Appropriate improvements in the transportation system and urban infrastructure are also in the works—including an elevated railway—along with preservation of ancient paths and construction of a network of cycling and nature trails. Through sifting, recreating, and celebrating the past, the city is poised to take an immense leap forward.

■ ■ ■

Too many aspects of life in today's Kyoto and Nara have gone unmentioned, but space here is limited. An entire book might be devoted to the beauties of the seasons in each city, or to the colorful festivals, large and small, that constantly take place. Besides the Big Three festivals of Kyoto described earlier—and of course festivities at New Year's and Obon—Kyoto has more than sixty major festivals and hundreds of smaller ones, ranging from athletic (a horseback archery contest) to elegant (a recreation of a Heian poem-writing contest), raucous (a naked dance), and solemn (a candle-lighting ritual in a cemetery).

Nara, too, is full of spectacle. In January, at Yamayaki, or "mountain-burning," the slopes of Mt. Wakakusa are set ablaze in a spectacular New Year's rite. At Omizutori, a rite of spring dating from the mid-eighth century, priests of Todai-ji undergo austerities to expiate the sins of humankind; the rite culminates at night when ten enormous torches are carried round and round the veranda of Nigatsu-do, showering purifying sparks and embers on surging spectators. On Sundays in October, one can watch from a gallery as the sacred deer of Kasuga Taisha are lassoed and have their antlers sawn off by a shrine priest. At Wakamiya Shrine, a temporary forest sanctuary is erected each December for the resident deity, who is transferred there by night in an atmosphere of mystery. For the next two days and two nights, against this primal backdrop, a succession of performances is offered for the deity's entertainment (and incidentally that of the assembled spectators): stylized *kagura* dances, folk pantomimes, sacred sumo, masked dances (*bugaku*), No theater, and more.

Finally, a reminder that while we have focused here on the cities mainly as busy urban environments, some of the greatest pleasures they have to offer are quiet and bucolic. Ohara, on the northern outskirts of Kyoto, is a rustic village containing two of the quietest and most beautiful temples anywhere in Japan: Jakko-in and Sanzen-in. Even in the city center, a stroll through the vast grounds of the Imperial Palace is a tranquil and meditative experience.

A delightful way to spend a bright fall afternoon is to take a one-and-a-quarter mile (two-kilometer) hike through the hills on the Kyoto-Nara prefectural border, between the temples Gansen-ji and Joruri-ji. The pathway is lined with mossy stone Buddhas and persimmon trees loaded with bright-colored fruit, and the temples are lovely. Yamanobe-no-michi, said to be the oldest road in Japan, is another rustic attraction; it runs ten miles (sixteen kilometers) from Nara to the town of Sakurai, past an assortment of imperial tombs, temples, and shrines. And right in the city, on sacred Mt. Kasuga, there is a primeval forest with great, centuries-old trees.

Whatever changes come to Kyoto and Nara, these historic cities are sure to remain alluring places that offer a range of experiences unavailable anywhere else.

NARA

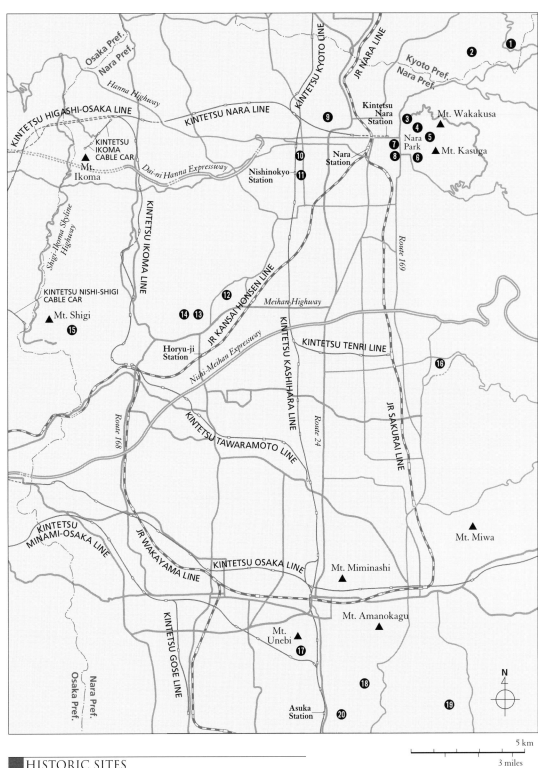

5 km

3 miles

■ HISTORIC SITES

❶ Gansen-ji temple
❷ Joruri-ji temple
❸ Shoso-in repository
❹ Todai-ji temple
❺ Kasuga Taisha shrine
❻ Shinyakushi-ji temple
❼ Kofuku-ji temple
❽ Gango-ji temple
❾ Heijo Palace site
❿ Toshodai-ji temple

⓫ Yakushi-ji temple
⓬ Hoki-ji temple
⓭ Chugu-ji temple
⓮ Horyu-ji temple
⓯ Chogosonshi-ji temple
⓰ Isonokami-jingu shrine
⓱ Kashihara-jingu shrine
⓲ Asuka-dera site
⓳ Tanzan-jinja shrine
⓴ Takamatsuzuka Mound

NOTES TO THE PLATES

A number of the sites and objects in this book have received recognition for their cultural significance. These designations, noted at the end of each caption, are as follows: WHS indicates a UNESCO World Heritage Site, NT a National Treasure (Kokuho), and ICP an Important Cultural Property (Juyo Bunkazai).

PAGE 1: **Red maple leaves against blinds.** These traditional blinds, known as *Kyo-sudare*, are handcrafted in Kyoto from split bamboo or reed. Practical and attractive, they admit light and air while ensuring privacy. *Kyo-sudare* can be found throughout the city in tea-ceremony houses and wooden *machiya* townhouses, as well as in the old geisha quarter of Gion.

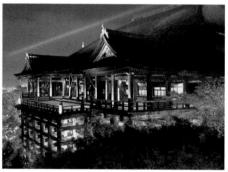

PAGES 2–3: **The main hall of the temple Kiyomizu-dera, lit up at night.** The wooden terrace of Kiyomizu-dera, a Kyoto landmark, affords a spectacular panoramic view of the city. The platform is supported by 139 pillars. Though the temple itself predates the city, it was burned down repeatedly; the present hall was built in 1633. NT (main hall), WHS (temple).

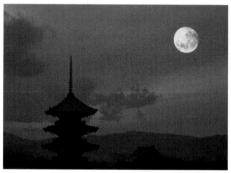

PAGES 4–5: **The five-story pagoda of the temple To-ji under a full moon.** To-ji dates back to 794, the founding date of ancient Heiankyo (present-day Kyoto). Its pagoda, a beloved symbol of Kyoto, is the tallest in Japan, a towering 180 feet (55 meters) high. Originally built by the monk Kukai (Kobo Daishi; 774–835) in 826, the pagoda was destroyed by lightning on numerous occasions; the present structure dates from 1644. NT (pagoda), WHS (temple).

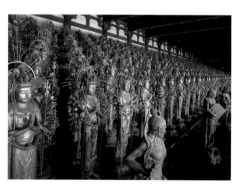

PAGES 6–7: **Statues of the Thousand-armed Kannon in the temple hall Sanjusangen-do.** One thousand images of the bodhisattva Kannon, dating from the twelfth and thirteenth centuries, are carved of Japanese cypress and covered in gold leaf. They are housed in Sanjusangen-do (Hall of Thirty-Three Bays), a part of the temple Myoho-in. Nearly 40 yards (120 meters) in length, it is the longest wooden building in Japan. ICP (standing statues), NT (hall).

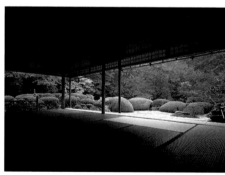

PAGES 8–9: **Autumn foliage in the temple garden of Shisen-do (Poets' Hall).** Located in the northern part of the Eastern Hills, Shisen-do was built as a thatch-hut hermitage in 1641 by samurai-turned-poet and scholar Ishikawa Jozan (1583–1672). It is dedicated to thirty-six classical Chinese poets. In front of the study is a garden of dry sand with dwarf azaleas and crimson maples.

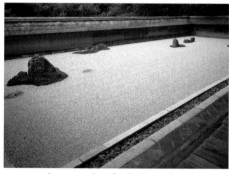

PAGE 10: **A rectangle of raked sand and stones on temple grounds: the Zen garden of Ryoan-ji.** This is the quintessential *karesansui*, or "dry landscape," garden, with raked white sand and fifteen moss-fringed stones enclosed in a clay wall. Starkly abstract, the five-hundred-year-old Zen garden shows the influence of Chinese monochrome ink-painted landscapes. WHS (temple).

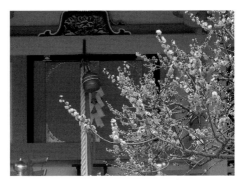

PAGE 11: **Pink plum blossoms at the shrine Kitano Tenman-gu.** This shrine is dedicated to Sugawara no Michizane (845–903), a scholar, calligrapher, and statesman of noble birth who was exiled to Kyushu and later deified as the patron god of learning. Plum (*ume*) blossoms were his favorite, and they are a symbol of the shrine.

PAGE 11: **Cascading wisteria at the Kyoto Imperial Palace.** These ravishing flowers in the Wisteria Courtyard (Fujitsubo) of the old palace bring to mind a character in the classic Heian novel *The Tale of Genji* who is associated with that name. Genji's forbidden love for his beautiful stepmother haunted him throughout his life.

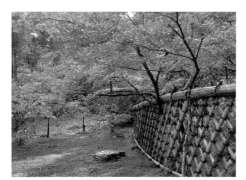

PAGE 11: **A fence of woven bamboo in the tea garden of the temple Koetsu-ji.** In 1615, the tea-master and artist Hon'ami Koetsu (1558–1637) retired to the northwest of Kyoto, where he organized a small community of craftsmen. This much-admired garden fence of woven bamboo (*Koetsu-gaki*) that also bears his name was created for the garden. The temple, famous for its fall leaves, is closed from November 10 to 13.

PAGES 12–13: **A narrow lane in the Kiyamachi district at twilight.** Narrow alleyways such as this one wind through older neighborhoods of Kyoto, helping to give the old capital its distinctive allure. Water splashed on stone-lined paths and wooden grates placed over windows add to the ambience, and also help to keep residents cool on sultry summer evenings.

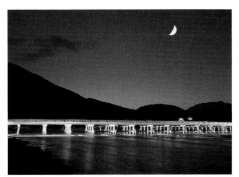

PAGES 14–15: **The Togetsu (Moon-crossing) Bridge in Arashiyama, over the Katsura River.** The area around this famed wooden bridge is one of the most popular scenic spots in the Arashiyama area of Kyoto, noted for cherry blossoms and autumn leaves. In Heian days, the aristocracy was fond of boating on this river.

PAGE 16: **Temple garden of the chief abbot's chamber in Tofuku-ji.** The checkerboard design of this twentieth-century garden contrasts square-cut stone with soft, lush moss. One of Kyoto's great Zen temples, Tofuku-ji was founded in 1236; this garden was added in 1939 by landscape architect Shigemori Mirei (1896–1975). Tofuku-ji is also known for the brilliance of its autumn foliage.

PAGE 17: **Decorated imperial carriage used in the Aoi Festival.** The Aoi Festival dates from the sixth century and took its present form in the Heian period. Every spring, an imperial messenger on horseback leads a procession from Kyoto Imperial Palace to Shimogamo and Kamigamo shrines, re-enacting an ancient plea to end rains and flooding. Here we see the wheel of a lacquered cart.

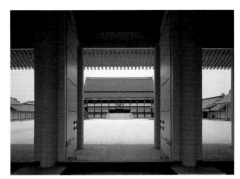

PAGE 18: **The palace throne hall, Shishin-den.** One of the old palace's most important halls, Shishin-den is where the Meiji, Taisho, and Showa emperors were all enthroned. Its roof has a covering of cypress-bark shingles twelve inches (thirty centimeters) thick. The vast rectangular yard of raked white gravel is a sacred space.

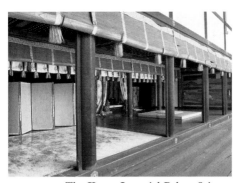

PAGES 18–19: **The Kyoto Imperial Palace Seiryo-den (Residence Hall).** In Heian times, this was the emperor's private residence. It is located behind the throne hall. Together, the two buildings are the only examples in the old palace of Heian *shinden-zukuri*-style architecture.

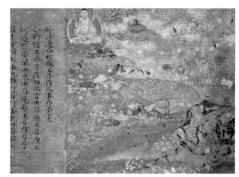

PAGE 20: **End of a sutra copy given to Itsukushima Shrine in 1164 by Taira no Kiyomori.** This lavishly illuminated scroll of the Lotus Sutra, one of a set of thirty-three called *Heike Nokyo*, is among the most splendid works of Japanese art. A woman is shown holding the scroll in question (*Yakuobon*) as Amida Buddha arrives to welcome her to the Pure Land. Between the two figures is a lotus pond. NT.

PAGE 20: ***Waka* poetry by courtier-poet Oshikochi no Mitsune, from a decorated book in the multi-volume *Sanjurokunin-kashu* anthology; housed at the temple Nishi Hongan-ji.** This elegant poetry anthology uses colored and figured paper decorated with painted patterns or pictures, sometimes with a scattering of gold and silver leaf. *Karakami* (Chinese paper) produced in Japan, wrinkled *michinoku-gami*, and "flowing-ink" paper are skillfully combined in the "torn-and-patched" style and other ways to create an infinite variety. NT (anthology).

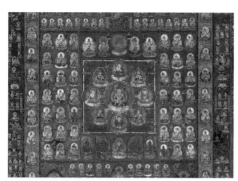

PAGE 21: ***Womb-World Mandala* from *Mandala of the Two Worlds*, at the temple To-ji.** The mandala, a graphic representation of the spiritual universe and an aid to meditation, is at the core of Japanese esoteric Buddhist practice. This late ninth-century mandala, one of a pair at the temple To-ji, depicts Mahavairocana, the cosmic Buddha, in all his physical manifestations. Colors on silk. NT.

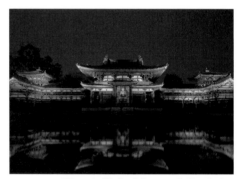

PAGES 22–23: **Phoenix Hall of the temple Byodo-in, Uji.** Japan's most famous building, popularly known as Phoenix Hall, was built in 1053 to symbolize both Buddhism's Western Paradise and the concept of immortality. Crowned with a pair of bronze phoenixes, the seemingly weightless structure suggests a bird with wings outstretched. Through a porthole in the grille, Amida Buddha gazes out serenely on the pond. NT (Phoenix Hall), WHS (temple).

PAGE 24: **Gate of the Three Luminaries, at the shrine Kitano Tenman-gu, with plum blossoms.** This shrine was built in the memory of Sugawara no Michizane (845–903), a Heian noble fond of plum blossoms who died in exile. Home to some two thousand plum trees, the shrine also features plum blossoms as a decorative motif on lanterns, tiles, and the woodwork. A flea market is held here on the twenty-fifth day of every month. ICP (gate).

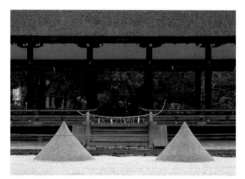

PAGE 25: **Two sand cones in the shrine garden of Kamigamo.** Founded in 678 as a tutelary shrine of the Kamo family, Kamigamo shrine is dedicated to the god of thunder. Until 1863, the Kamigamo (upper Kamo) and Shimogamo (lower Kamo) shrines were rebuilt every twenty-one years in line with Shinto tradition. The sand cones in front of the Hoso-dono sanctuary, representing sacred mountains, are for purification. WHS (shrine), ICP (sanctuary).

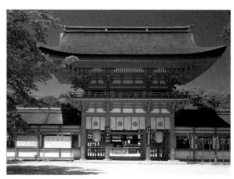

PAGE 25: **The vermilion shrine gate of Shimo-gamo.** This most ancient of Kyoto's shrines is located in the north of the city where the Kamo and Takano rivers come together, and it enshrines the goddess of water, mother of the god of thunder. The shrine complex is peaceful and quiet, surrounded by woods that shut out the city din. ICP (gate), WHS (shrine).

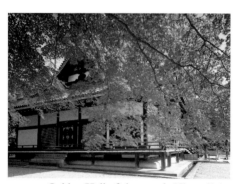

PAGE 26: **Golden Hall of the temple Ninna-ji, in autumn.** Ninna-ji was completed in 888 by Emperor Uda, who later became its abbot. Until Meiji times, tonsured sons of the imperial family filled the position of head priest. In the seventeenth century, Ninna-ji was presented with two old palace buildings, one of which was dismantled and rebuilt into the Golden Hall. NT (hall), WHS (temple).

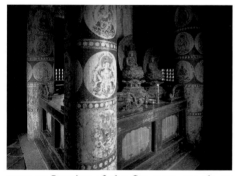

PAGE 26: **Interior of the five-story pagoda at Ninna-ji.** The imposing pagoda of Ninna-ji dates from the seventeenth century. A pagoda is essentially a monument, with little usable interior space, but here we see a pair of gilt icons ensconced on a central dais, surrounded by decoratively painted round columns. ICP (pagoda).

PAGE 27: **A monk in traditional pilgrim garb performs** *kaihogyo* **(mountain training) on forested Mt. Hiei.** This discipline of the Tendai sect requires the adept to walk 18 miles (30 kilometers) a day for 100 days over a period of a year. After a still more grueling 1,000-day course (completed over a span of 7 years), during which he must survive 9 consecutive days without food, water, sleep, or rest, he may become a "living Buddha."

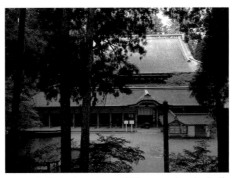

PAGE 27: **Exterior view of Konponchu-do hall, at the temple Enryaku-ji, Mt. Hiei.** Enryaku-ji, an important center of the Tendai sect of Buddhism, was founded in 788 on the eastern slope of Mt. Hiei, northeast of Kyoto, by the monk Saicho (767–822). The once-militant temple complex was razed in 1571 by Oda Nobunaga (1534–82). This central hall was reconstructed in 1642 by the Tokugawa shogunate. NT (hall), WHS (temple).

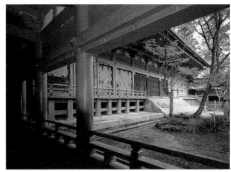

PAGE 27: **Konponchu-do hall as seen from a linked corridor.** This beautiful hall is the third-largest wooden structure in Japan. Nestled in the mountain forest along with some two hundred other buildings, it is located in the most important of Enryaku-ji's three sections.

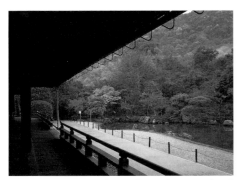

PAGE 28: **Sogen Pond seen from the veranda of Ohojo on the grounds of Tenryu-ji.** Tenryu-ji features a Zen garden built around Sogen Pond, with "borrowed scenery" of the Arashiyama and Kameyama ranges in the background. The large area of white sand reaching to the pond further enhances the view. WHS (temple).

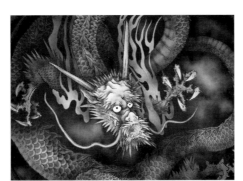

PAGES 28–29: **Ceiling painting of a dragon by Kayama Matazo, in the temple building Hatto of Tenryu-ji.** Tenryu-ji (Heavenly Dragon Temple) was founded in 1339 by Muso Soseki (1275–1351) under the patronage of shogun Ashikaga Takauji (1305–58), in honor of the memory of Emperor Go-Daigo (1288–1339). It is the principal temple of the Tenryu-ji school of the Rinzai sect. This figure of a Cloud Dragon was painted in 1997.

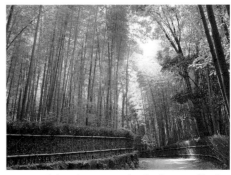

PAGE 30: **A bamboo grove in the Sagano district of Kyoto.** The Sagano area, across Togetsu Bridge in Arashiyama, is famous for its temples and villas, but above all for the beauty of its bamboo groves, long celebrated in poetry and song.

PAGE 30: **Firelight No performance at the shrine Heian Jingu.** On the first two evenings of June, performances of No are held by torchlight in the front court of Heian Jingu. The flickering firelight and magnificent shrine grounds provide a perfect foil for the mysterious beauty of the ancient dance-drama with its masks, gorgeous costumes, and solemn, unearthly music.

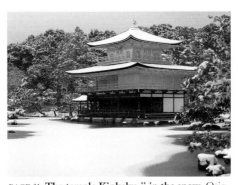

PAGE 31: **The temple Kinkaku-ji in the snow.** Originally an aristocrat's villa and the center of Ashikaga power, the estate was converted to a Zen temple in 1408. The celebrated three-story golden pavilion was burned down by a deranged priest in 1950, and rebuilt in 1955. The twenty-four-carat gold leaf covering the two upper stories was completely replaced in 1987. WHS (temple).

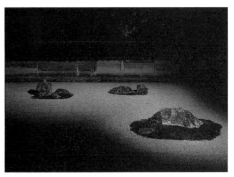

PAGE 32: **A temple garden in moonlight, Ryoan-ji.** Simple yet ultimately incomprehensible, this garden is the purest expression of the Zen ideal in its studied elimination of color and extraneous detail. The shifting quality of light subtly changes the features of the garden. Here the light of the full moon adds to the mood of contemplation. WHS (temple).

PAGE 33: **"Splashed ink" landscape painted by Sesshu in 1495.** This is the crowning masterpiece of Zen painter Sesshu Toyo (1420–1506). At age 75, he created a new style of painting. Using *sumi* ink on wet paper, with sure, masterful strokes he suggests an inn beneath a tree, a small boat with figures, and looming, distant mountains. Housed in the Tokyo National Museum. NT.

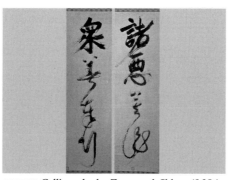

PAGE 33: **Calligraphy by Zen monk Ikkyu (1394–1481): "Refrain from evil, carry out good."** The eccentric wandering monk Ikkyu Sojun was an exuberant lover, poet, and calligrapher who railed against the hypocrisy of established Zen. His unorthodox style, brimming with vitality, opened up a new spiritual dimension in calligraphy. Late in life he became chief abbot of the temple Daitoku-ji, where this work is housed. ICP.

PAGE 33: **A temple priest of Myoshin-ji engaged in Zen meditation.** Myoshin-ji, the principal temple of the Rinzai school of Zen, was founded in 1337 by retired emperor Hanazono (1419–71). The Rinzai school emphasizes two forms of meditation: *zazen,* or meditation in the lotus position, and *koan,* questions for meditation. The first derives from the Indian yoga tradition, the second from early Chinese Zen.

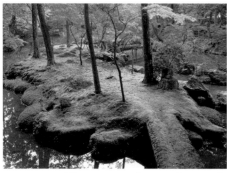

PAGES 34–35: **The moss garden at the temple Saiho-ji.** Belonging to the Rinzai sect of Zen Buddhism, Saiho-ji is celebrated for its teahouse and moss garden, from which comes the popular name of the temple, Koke-dera (Moss Temple). Designed by Muso Soseki (1275–1351) in 1339, the exquisite garden features over one hundred and twenty different species of moss. WHS (temple).

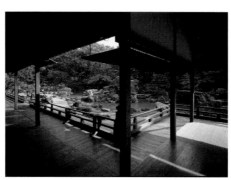

PAGES 36–37: **The garden of Sanbo-in (House of Three Treasures) at the temple Daigo-ji.** The Sanbo-in subtemple of Daigo-ji was founded in 1185 and rebuilt by Toyotomi Hideyoshi in the late 1500s. The elaborate garden is said to have been designed by the famous warlord himself. NT (building), WHS (temple).

PAGES 38, 39: **Tea room interior with tea utensils at the inn Sumiya.** The influence of Zen transformed once-opulent tea parties for the rich into something serene, austere, and profound, enjoyed by aristocrat and commoner alike. ■ **A bowl of** *usucha.* Matcha, the powdered tea used in the tea ceremony, comes in two varieties. Traditionally, *usucha,* or "weak tea," is made from young tea leaf buds and has an astringent taste; *koicha,* or "strong tea," is made from older buds and has a mellower, sweeter flavor. Photo from *Cha no kokoro* by Sen Soshitsu XV, published by Tankosha.

PAGE 39: **Flowers for the tea ceremony at a teahouse in Juko-in.** Flowers are an indispensable part of teahouse décor. They are placed unostentatiously in a basket or vase, to appear as they would in the field. This unassuming teahouse belongs to a subtemple of Daitoku-ji called Juko-in, the burial place of grand teamaster Sen no Rikyu. ICP (teahouse).

PAGES 40–41: **Detail from** *Genre Scenes in Kyoto* **(Funaki version), depicting seventeenth-century Kyoto.** The genre of folding-screen paintings of scenes in and around the capital originated in the Muromachi period (1333–1573). This work, housed in the Tokyo National Museum, is from around 1615. It provides a window on the culture, manners, and customs of the times. Left screen of a pair of six-panel screens. ICP.

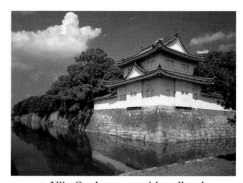

PAGE 42: **Nijo Castle turret, with wall and moat.** Nijo Castle was begun in 1569 by warlord Oda Nobunaga, and completed by Tokugawa Ieyasu (1543–1616) as a residence for shoguns visiting Kyoto. It is famous for its "nightingale floors," made to creak deliberately to warn of potential assassins. The corner watchtower with whitewashed walls is striking. ICP (turret).

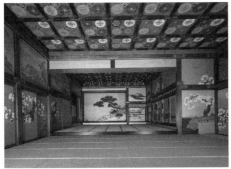

PAGES 42–43: **The audience hall of Ninomaru Palace on the Nijo Castle grounds.** The shogun and his retinue sat on the raised section of this opulent hall, called Kuroshoin, and *daimyo* paying him obeisance knelt and prostrated themselves on the lower section. Completed around 1625, the hall exemplifies *shoin* style, with tatami mats, a *tokonoma* alcove, staggered shelves, and decorative doors. NT (palace), WHS (castle grounds).

PAGE 44: **From the east garden of the middle study looking across the music room to the new palace.** This view emphasizes the rustic simplicity for which this country retreat, built by seventeenth-century aristocrats, is much admired. The rhythmic repetition of plain rectangular elements finds echo elsewhere in tatami mats and paving stones. The clean lines, natural materials, and integration of interior and exterior space seem modern even today.

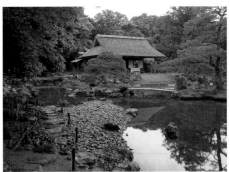

PAGE 45: **The Shokintei teahouse seen from the** *suhama* **(sandy beach).** This thatched-roof teahouse, located picturesquely beside the pond to the east of the main house, is called Shokintei, or Pine Lute Pavilion. Stepping stones lead to the pond, where guests can rinse their hands before joining in a tea ceremony.

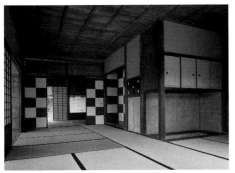

PAGE 45: **Interior of the Shokintei teahouse.** Here again we see a striking repetition of rectangular forms. This view is from the northwest corner of the first room in the teahouse, looking toward the *tokonoma* alcove and second room, and on out into the garden.

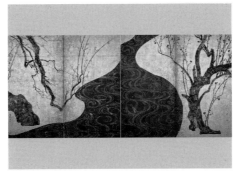

PAGE 46: **"Red and White Plum Blossoms," a pair of two-panel folding screens by Ogata Korin (1658–1716), color on gold foil over paper.** This is an eighteenth-century masterpiece of the highly influential Rinpa school, a decorative school of painting typically employing precious materials such as gold and silver, together with rich colors, on screens, fans, and other items. The work is characterized by bold composition and abstraction, combined with keen observation of nature. Housed by MOA Museum of Art, Atami, Japan. NT.

PAGE 46: **Detail of Korin's screen.** The son of a Kyoto textile merchant, Korin rose to fame during the Genroku era (1688–1704), the time of greatest cultural flowering under the Tokugawa shogunate (1603–1868). The decorative, energetic, and realistic style of his painting earned Korin many followers. Notice the mottled texture of the tree trunk and branches.

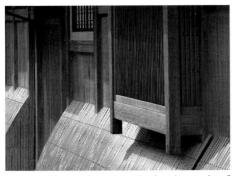

PAGE 47: *Inuyarai*, **a protective barrier made of curved bamboo fronting a traditional Kyoto home.** The front of this traditional *machiya* (Kyoto townhouse) features slatted *koshi* doors and windows. Houses run to the street's edge, so the latticework affords residents a measure of privacy. The curved barrier helps to protect the lower part of the wall from soiling or damage.

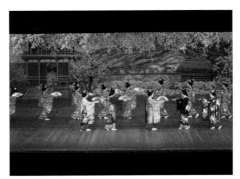

PAGES 48–49: **Miyako Odori (Cherry Blossom Dance) performed by apprentice and full-fledged geishas.** The graceful mood of Kyoto is captured by the *maiko* apprentices and their sister geisha in a gala tribute to spring. This annual performance in Gion is one of the best ways to observe Kyoto's traditional dance forms.

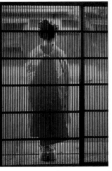

PAGES 50, 51: **An apprentice geisha seen through a lattice door.** *Maiko* (apprentice geisha) are cultural icons of Kyoto, epitomizing beauty, grace, and dedication to traditional performing arts. ■ **Plum blossom** *hana-kanzashi*, **a hair ornament worn by apprentice geishas.** *Maiko* wear hair ornaments matched to the season, featuring flowers fashioned from squares of silk.

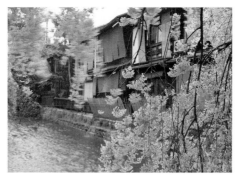

PAGE 51: **Weeping cherry trees in the Gion district.** Beside the stream in Gion, the old geisha district in eastern Kyoto, branches of weeping cherry are heavy with blossoms. In the background, teahouse verandas hung with blinds preserve the traditional atmosphere of this culturally important area.

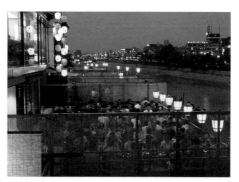

PAGE 52: **Summer evening on a waterfront deck by the Kamo River.** From May 1 to September 30, Kyotoites can escape the summer heat, and take in the cityscape at night, by enjoying an open-air repast on temporary wooden decks set along the west bank of the Kamo River. This pleasant custom goes back centuries.

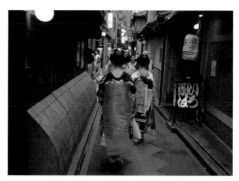

PAGE 52: **Apprentice geishas walking down a lane in Pontocho.** The traditional entertainment district of Pontocho is a magical place at night, where old wooden buildings and festive lanterns create the illusion of another world. It is also a likely place to spot *maiko* on their way to an evening engagement—a tantalizing glimpse of Kyoto's living past.

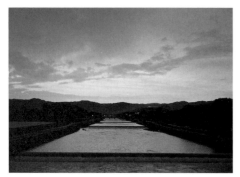

PAGES 52–53: **Sunset over the Kamo River.** The Kamo River flows south through the city to join the Katsura River. Clean and beautiful, it is visited by egrets even in the city center, and anglers continue to fish its waters for trout. The river has cultural associations as well; the classical Kabuki theater originated in the dry riverbed in 1603.

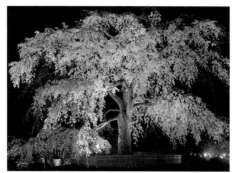

PAGES 54–55: **The weeping cherry tree of Maruyama Park at night.** This park is the most popular public place in Kyoto for night-time cherry-blossom viewing. In April, the venerable tree is lit up every night from sunset till one in the morning, and people gather nearby to sip saké, sing, and contemplate the brief but glorious life of the cherry blossom.

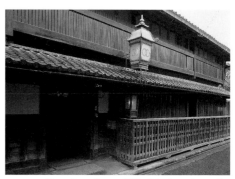

PAGE 56: **Exterior view of Wachigaiya.** Atop the tile roof of the latticed exterior is a gaslight decorated with linked circles, the crest of this one-time residence for geishas and *tayu* (premiere geishas). The name of the building derives from this emblem. Wachigaiya proudly boasts a 300-year history as an *okiya* (geisha residence), and 130 years as a licensed teahouse.

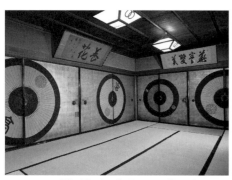

PAGES 56–57: **The Umbrella Room of Wachigaiya.** Wachigaiya was renovated in 1871, and has a dozen or more rooms for entertaining customers. Here, actual oiled-paper umbrellas from the seventeenth century are mounted on sliding *fusuma* doors covered in solid silver leaf. In the shadowy, candle-lit interior, the boldness of this design is striking.

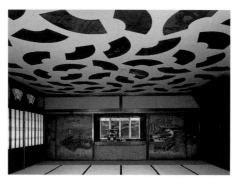

PAGE 58: **The Fan Room of Sumiya.** The ceiling of this room is papered with fans decorated by artists and calligraphers from a variety of schools; there are an amazing fifty-eight in all. The door-pulls on the sliding *fusuma* doors are also fan shaped, as are the transom windows above the translucent *shoji* doors on the left. ICP (building).

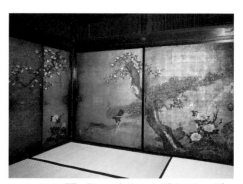

PAGES 58–59: **The Peacock Room of Sumiya.** The gold-leaf *fusuma* doors of this room are lavishly decorated with paintings of peacocks, peonies, and flowering trees by Emura Shunpo, an Edo-period painter of the Kano school. Other rooms contain works by outstanding artists such as Yosa Buson, Maruyama Okyo (1733–95), and Kishi Ganku (1756–1836).

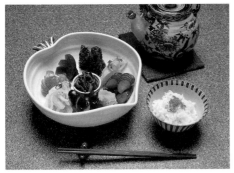

PAGE 60: **Kyoto-style pickles made from local vegetables at Kintame, a combination shop and restaurant.** The pickles of Kyoto are renowned for their color, taste, and variety. Kintame is a famous Kyoto pickles manufacturer, dating back more than 120 years. Visitors can learn about various pickles and sample them, or enjoy them with a full meal.

PAGE 60: **A colorful assortment of *namafu* (delicacies made from wheat gluten) at Fuka.** Wheat gluten is made by kneading wheat flour and water, then adding glutinous rice flour and millet, and finally steaming or boiling the mixture. Fuka, located in a traditional wooden *machiya* townhouse, still makes wheat gluten products (*namafu*) for imperial functions.

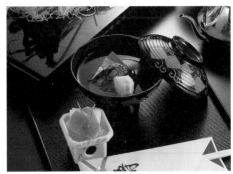

PAGE 61: **Kyoto-style New Year's cuisine at the restaurant Tankuma Kitamise.** The festive menu includes dried mullet roe with *daikon* radish: soup with toasted rice cake, red and white minced and steamed clam, sliced *daikon* radish and carrot, and a sprig of Japanese pepper; lobster sashimi with *iwatake* mushroom (a black lichen collected from cliff faces); and citron stuffed with *shiso*, horseradish, and red ginseng.

PAGE 62: **The traditional entrance of Tawaraya Yoshitomi.** For generations, the family running this shop supplied sweets for the imperial family and those living within the bounds of the imperial palace grounds. Today the shop supplies the general public with an astonishing array of Japanese sweets.

PAGES 62, 63: ***Kinton* confections made from bean and a design sketchbook, also from Tawaraya Yoshitomi.** On the left are handcrafted confections associated with (from the top of the color page) January, February, March, and April. Sophisticated use of design and color, as well as the delicate expression of the seasons, are traditional hallmarks of Kyoto confections. The design sketchbook is a valuable sourcebook used in planning one-of-a-kind tea ceremonies.

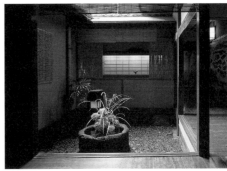

PAGE 64: **A courtyard garden at the inn Tawaraya.** The *tsuboniwa*, or courtyard garden, can be made in the space of one *tsubo*, or 36 square feet (3.3 square meters). Kyoto is the birthplace and home of such inner courtyard gardens. In Tawaraya, a dark corridor of polished wood zigzags past a lanterned space where flowers are set off to perfection.

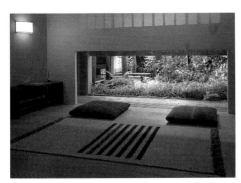

PAGE 64: **A reading room at Tawaraya.** This inviting room combines traditional and modern features. Lighting is soft, and the wide, low opening that looks out on the courtyard garden provides a sense of quiet and privacy while letting in plenty of light. Interior and exterior are well integrated.

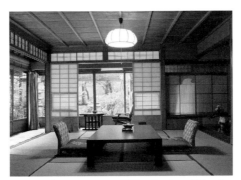

PAGE 65: **A guestroom at Hiiragiya inn.** Hiiragiya was the favorite inn of Nobel Prize-winning novelist Kawabata Yasunari (1899–1972). This guestroom is spacious and restful with a private garden view. The unostentatious beauty of this warmly welcoming room represents the finest in traditional accommodation.

PAGE 66: **A striking design of Kyoto embroidery.** From earliest times, embroidery was practiced in Japan, especially in the portrayal of Buddhist subjects and mandala hangings. Beginning in the Azuchi-Momoyama period (1568–1600) it was applied to a newly simplified style of kimono, with magnificent pictorial designs in brilliantly colored silk thread.

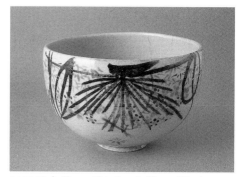

PAGE 67: **A *Kyo-yaki* teabowl.** *Kyo-yaki* is the general term for all ceramics produced in and around Kyoto, except for red or black Raku ware. It covers a variety of styles, generally of high technical proficiency and decoration. Three-colored lead-glazed ware was made as early as the eighth century.

PAGE 67: **A Kyoto-style painted fan.** The folding fan is a Japanese invention, centered in Kyoto. These superbly crafted and decorated fans are also of immense practical value, combining beauty of form and function. Long popular at court, they were also adapted for use in No drama, classical dance, and the tea ceremony. The fan here shows scenes of Heian aristocratic life.

PAGE 67: **Detail of a kimono *obi* sash of Nishijin brocade.** The magnificent brocades made in Nishijin, Kyoto's famous silk-weaving district, are perhaps the world's finest. This detail shows an *obi* sash richly brocaded with graceful cranes, leaves, and swirling water, in hues of understated elegance.

PAGE 68: **Lanterns glow on the *Kitakannon-yama* float in the Gion Festival.** The month-long Gion Festival began as a joyous tribute to the divinities of Yasaka Shrine for ending a plague in the summer of 869. On the evenings of July 14 to 16, people dressed in summer *yukata* fill the streets to admire the lantern-festooned floats, listen to festival music, and enjoy a convivial atmosphere.

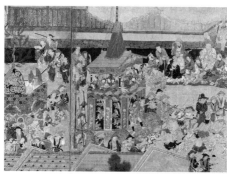

PAGE 69: **Detail of a seventeenth-century folding screen showing a float touring downtown Kyoto in the Gion Festival.** On July 17, the thirty-two floats are borne through the main streets of central Kyoto. Many are decorated with antique textiles, art objects, mechanical figures, or elaborate scenes. Ten are wheeled, like this one, and convey bands of musicians playing flute, drum, and gong music called Gion-bayashi. From the collection of Museum für Ostasiatische Kunst, Köln, Germany (no. Aa34).

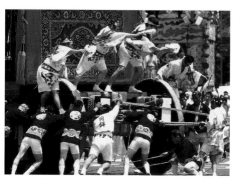

PAGE 70: **Turning the corner is achieved by pulling the massive float sideways over wet bamboo slats.** One of the most interesting spectacles during the July 17 parade of the Gion Festival is the turning of the heavy floats at an intersection. Lacking any steering mechanism, the floats are pivoted using blocks of wood. Bamboo slats are laid under the wheels and doused with water to reduce friction as men in *happi* coats strain and cheer. The parade of floats is designated an Important Intangible Folk Cultural Property.

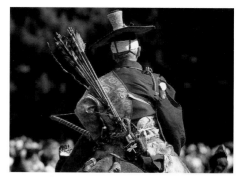

PAGE 71: **A Festival of the Ages participant dressed as a horseback archer.** Equestrian archery (*yabusame*) is said to date back to the sixth century, and later it became a samurai skill. This festival, a costume parade of people dressed as the various players in Kyoto's long history, originated in 1895 to celebrate the city's first eleven hundred years.

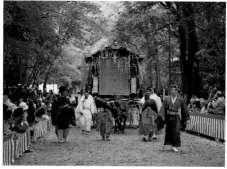

PAGE 71: **An ox-drawn cart decorated with wisteria as part of the Aoi Festival.** Japan's oldest festival reenacts a sixth-century imperial procession bearing gifts for the deities of two venerable shrines. Lavish costumes celebrate the glorious Heian aristocratic culture. Leaves of *aoi* (hollyhock) adorn the costumes of participants, as they walk the route from the old Imperial Palace to Shimogamo and Kamigamo shrines.

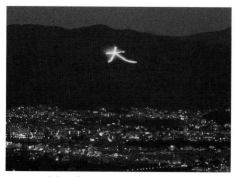

PAGE 72: **A bonfire in the shape of the character *dai* (great), a part of the Fire Festival.** During midsummer Obon, Japanese pay respect to the spirits of their ancestors. On the night of August 16, fires in various symbolic shapes are lit in sequence on five mountains around Kyoto to bid the spirits farewell and guide them safely back to paradise.

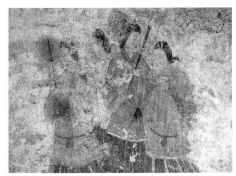

PAGE 73: **Painting of a group of women from the ancient Takamatsuzuka burial mound in Asuka.** The burial mound, possibly the tomb of an ancient Korean noble, was excavated in 1972, revealing brightly colored wall paintings from around 700. This painting on the west wall shows a group of four women, thought to be mourners, wearing long jackets and striped skirts of Korean style. NT.

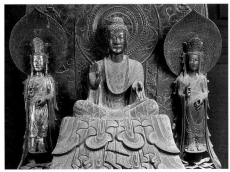

PAGE 74: **The Shaka (Sakyamuni) triad of Horyu-ji.** This triad, the temple's chief icon, was completed by Tori Busshi in 623, the year after Prince Shotoku's death. All the faces were made in the prince's likeness to ensure the repose of his soul. The cascading, flat folds of the costume, the slight smiles, and the large halo typify Asuka style. NT.

PAGES 74–75: **An aerial view of the Horyu-ji temple compound.** With its countless treasures, the ancient Horyu-ji monastery is the fountainhead of Japanese art and architecture. The compound contains the oldest wooden buildings in the world. It was founded in 601 by Prince Shotoku, the father of Japanese Buddhism. WHS, NT (four citations: pagoda, main hall, gate structure to left of pagoda, connecting corridor).

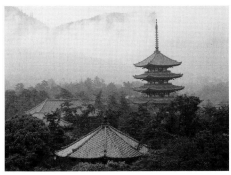

PAGE 76: **An aerial view of the temple Kofuku-ji with Mt. Kasuga in the background.** The outlines of the Kofuku-ji, once a busy monastery sponsored by the Fujiwara family in the ancient capital of Heijokyo, blend in peacefully today with Nara Park. The present pagoda dates from 1462. WHS, NT (pagoda, Hokuen-do hall in foreground).

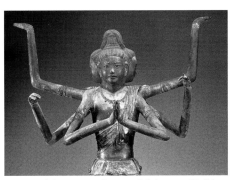

PAGE 77: **A lacquer sculpture of Ashura at Kofuku-ji.** This statue of the boy-god Ashura, the most famous of the statues in the National Treasure House of Kofuku-ji, represents one of the eight supernatural guardians of Sakyamuni. He is shown with three heads and six arms. Remarkably graceful and expressive, it is a masterpiece of eighth-century dry lacquer sculpture. NT.

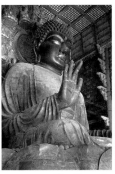
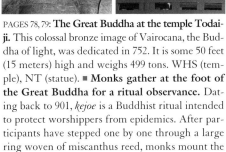

PAGES 78, 79: **The Great Buddha at the temple Todai-ji.** This colossal bronze image of Vairocana, the Buddha of light, was dedicated in 752. It is some 50 feet (15 meters) high and weighs 499 tons. WHS (temple), NT (statue). ■ **Monks gather at the foot of the Great Buddha for a ritual observance.** Dating back to 901, *kejoe* is a Buddhist ritual intended to protect worshippers from epidemics. After participants have stepped one by one through a large ring woven of miscanthus reed, monks mount the platform to perform a Buddhist service.

PAGE 78: **The sacred ceremony of *omizutori*, at Todai-ji.** *Omizutori* (water-drawing) is a rite of spring performed from March 1 to 14 at the Nigatsu-do hall of Todai-ji. Late on the night of March 12, torch-bearing monks race around the veranda scattering sparks over the crowd below in ritual purification. Then they draw water from a nearby well and offer it to the image of Kannon. ICP (building).

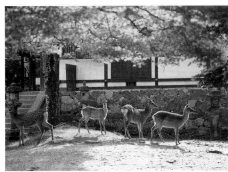

PAGE 80: **Deer in Nara Park.** Nara Park, established in 1880, is home to hundreds of freely roaming tame deer, considered sacred messengers of the gods.

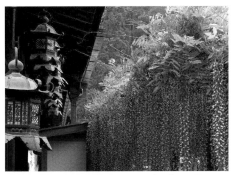

PAGE 80: **Lanterns and wisteria in the shrine Kasuga Taisha.** One of the oldest and most important Shinto shrines in Japan, Kasuga Taisha is located in an ancient forest at the foot of Mt. Mikasa and Mt. Kasuga in Nara. It is known for its thousands of lanterns, and for its wisteria. The name of the founding Fujiwara family means "wisteria field." WHS (shrine).

ACKNOWLEDGMENTS

The publisher would like to express its gratitude to all of the following temples, organizations, companies, and establishments for graciously granting permission to use the photographic images in the present volume:

Byodo-in (pages 22–23)
Daigo-ji (pages 36–37)
Enryaku-ji (page 27, all photographs)
Fuka (page 60, bottom)
Gion Festival Floats Association (pages 68, 70)
Gion Shinchi Kobu Kabukai (pages 48–49)
Hiiragiya (page 65)
Horyu-ji (pages 74, bottom left; 74–75)
Imperial Household Agency, Kyoto Office (pages 11, center; 18, bottom left; 18–19; 44; 45, top & bottom)
Itsukushima-jinja (page 20, top)
Juko-in, Daitoku-ji (page 39, bottom)
Kamigamo-jinja (page 25, top)
Kasuga Taisha (page 80, bottom)
Kintame (page 60, top)
Kitano Tenman-gu (pages 11, top; 24)
Kiyomizu-dera (pages 2–3)
Koetsu-ji (page 11, bottom)
Kofuku-ji (pages 76, 77)

Museum für Ostasiatische Kunst, Köln (page 69)
Myoho-in (pages 6–7)
Myoshin-ji (page 33, bottom right)
Nijo Castle (pages 42, bottom left; 42–43)
Ninna-ji (page 26, top & bottom)
Rokuon-ji (page 31)
Ryoan-ji (pages 10, 32)
Saiho-ji (pages 34–35)
Shimogamo-jinja (page 25, bottom)
Shinju-an, Daitoku-ji (page 33, bottom left)
Shisen-do (pages 8–9)
Sumiya Hozonkai (pages 58, left; 58–59)
Sumiya Ryokan (page 38)
Tankosha (pages 39, top & bottom; 60, bottom; 62, right; 63)
Tankuma Kitamise (page 61)
Tawaraya Ryokan (page 64, top & bottom)
Tawaraya Yoshitomi (pages 62, bottom left & right; 63)
Tenryu-ji (pages 28, bottom left; 28–29)
Todai-ji (pages 78, top & bottom; 79)
Tofuku-ji (page 16)
To-ji (pages 4–5, 21)
Tokyo National Museum (pages 33, top left; 40–41)
Wachigaiya (pages 56, bottom left; 56–57)

PHOTO CREDITS

Archivo Iconografico, S.A. (Corbis/Corbis Japan): pages 42–43
Asukaen: pages 6–7
Benrido: pages 20 (top), 21
Bon Color Photo Agency: page 47
Fukushima Umon: pages 11 (top; Bon Color Photo Agency), 80 (bottom; Sekai Bunka Photo)
Hashimoto Kenji (Sekai Bunka Photo): page 25 (top)
Hibi Sadao: pages 66 (bottom), 67 (top left)
Imperial Household Agency, Kyoto Office: pages 18–19
Inoue Hakudo: page 79
Inoue Takao: pages 38, 39 (top & bottom)
Irie Taikichi (Nara City Museum of Photography): pages 74–75, 76, 77
Ishimoto Yasuhiro: page 44
Iwanami Shoten (courtesy of Benrido): page 74 (bottom left)
JTB Photo: pages 24, 25 (bottom), 42 (bottom left)
Kobayashi Tsunehiro (courtesy of Tankosha): page 60 (bottom)
Kodansha Ltd.: pages 27 (bottom right), 33 (bottom left), 58 (left), 58–59, 78 (top & bottom)
Misawa Hiroaki: page 18 (bottom left)
Miyano Masaki: pages 62 (bottom left), 62 (right), 63, 64 (top & bottom)
Miyoshi Kazuyoshi (PPS): pages 26 (bottom), 27 (top right)
Mizobuchi Hiroshi: pages 30 (bottom; Sekai Bunka Photo), 48–49, 51 (top)
Mizuno Katsuhiko: pages 8–9, 12–13, 14–15
MOA Museum of Art: page 46 (top & bottom)

Murota Yasuo: pages 1 (Bon Color Photo Agency), 26 (top; Sekai Bunka Photo)
Nakata Akira: pages 52–53; pages 17, 71 (bottom), 72 (last three; Haga Library)
Nara National Cultural Properties Research Institute: page 73
Negishi Soichiro: page 67 (bottom left & right)
Nishi Hongan-ji (courtesy of Tokyo National Museum): page 20 (bottom)
Ohashi Haruzo: pages 36–37
Rheinisches Bildarchiv, Köln: page 69
Simmons, Ben: page 52 (top left & bottom left)
Sogo Kikaku Center: page 61
Straiton, Ken (PPS): page 65
Sudo Koichi: pages 2–3, 10, 11 (bottom), 33 (bottom right), 50, 60 (top), 68, 70, 71 (top)
Tabata Minao: page 45 (top & bottom)
Tanaka Hideaki (Bon Color Photo Agency): page 30 (top)
Tenryu-ji: pages 28–29
Tokyo National Museum: pages 33 (top left), 40–41
Tsuchimura Seiji (Bon Color Photo Agency): page 16
Yamamoto Michihiko: page 31
Yamanashi Katsuhiro (Sekai Bunka Photo): pages 54–55, 80 (top)
Yokoyama Kenzo: pages 11 (center), 22–23 (courtesy of Byodo-in), 27 (left), 28 (bottom left), 32, 51 (bottom), 56 (bottom left), 56–57
Yoshida Noriyuki: pages 4–5, 34–35

Maps by Omori Tadamitsu

英文ビジュアル版　京都——千年の輝き
Seeing Kyoto

2005 年 6 月　第 1 刷発行
2007 年 7 月　第 3 刷発行

著　者　　ジュリエット・カーペンター
発行者　　冨田　充
発行所　　講談社インターナショナル株式会社
　　　　　〒112-8652　東京都文京区音羽 1-17-14
　　　　　電話　03-3944-6493（編集部）
　　　　　　　　03-3944-6492（マーケティング部・業務部）
　　　　　ホームページ　www.kodansha-intl.com
印刷・製本所　大日本印刷株式会社

落丁本・乱丁本は購入書店名を明記のうえ、講談社インターナショナル業務部宛にお送りください。送料小社負担にてお取替えいたします。なお、この本についてのお問い合わせは、編集部宛にお願いいたします。本書の無断複写（コピー）は著作権法の例外を除き、禁じられています。

定価はカバーに表示してあります。

Printed in Japan
ISBN 978-4-7700-2338-4

CHRONOLOGY

JOMON PERIOD — c. 10,000–c. 300 B.C.

YAYOI PERIOD — c. 300 B.C.–c. A.D. 300

KOFUN PERIOD — c. 300–710

552 — Introduction of Buddhism from China.

607 — First official embassy to China.

645–50 — Taika Reform.

NARA PERIOD — 710–94

710 — Nara becomes Japan's first capital.

752 — Dedication of the Great Buddha of Todaiji temple, Nara.

781–808 — Reign of Emperor Kanmu.

HEIAN PERIOD — 794–1185

794 — The capital is moved to Heiankyo (Kyoto).

838 — Twelfth and last embassy to Tang China.

995–1027 — Supremacy of Fujiwara Michinaga, official of the imperial court.

c. 1002 — Sei Shonagon writes *The Pillow Book*, a diary of Heian court life.

c. 1008 — Murasaki Shikibu writes the *Tale of Genji*.

1180–85 — Genpei War between the Minamoto and the Taira clans, won by the Minamoto.

KAMAKURA PERIOD — 1185–1333

1191 — The monk Eisen returns from China and founds the Zen sect.

1192 — The title of shogun is granted to Minamoto no Yoritomo.

1219 — Minamoto no Sanetomo, the third shogun, is assassinated, ending the line of Minamoto shoguns.

MUROMACHI PERIOD — 1333–1573

1374–1408 — Noh drama flourishes through Kan'ami (1333–84) and Zeami (1363–1443) under the patronage of shogun Ashikaga no Yoshimitsu (1358–1408).

1392 — Reunion of the Northern and Southern Courts.

1397 — Kinkakuji (Golden Pavilion) temple built by Yoshimitsu.

1542 — Portuguese land at Tanegashima, an island south of Kyushu, and European firearms are introduced.

1549 — St. Francis Xavier (1506–52) arrives in Kyushu.

1568 — Oda Nobunaga (1534–82) occupies Kyoto.

AZUCHI-MOMOYAMA PERIOD — 1568–1600

1573 — Nobunaga consolidates his power and the fighting ends.

1682 — Nobunaga is assassinated by Akechi Mitsuhide; Toyotomi Hideyoshi (1536–98) succeeds him.

1586 — Osaka Castle is built by Hideyoshi.

1587 — Sen no Rikyu (1522–91) officiates the grand tea ceremony held in Kitano, Kyoto, under the sponsorship of Hideyoshi.

1589 — Christianity is proscribed.

1600 — Tokugawa Ieyasu (1542–1616) wins the Battle of Sekigahara.